MW00577884

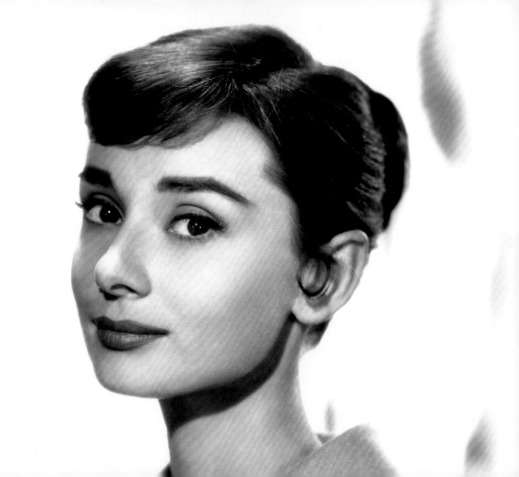

Audrey Hepburn

A PHOTOGRAPHIC CELEBRATION

Skyhorse Publishing books may be purchased in bulk at special discounts for sales promotion, corporate gifts, fundraising, or educational purposes. Special editions can also be created to specifications. For details, contact the Special Sales Department, Skyhorse Publishing, 307 West 36th Street, 11th Floor, New York, NY 10018 or info@skyhorsepublishing.com.

Visit our website at www.skyhorsepublishing.com.

10 9 8 7 6 5 4 3 2

Library of Congress Cataloging-in-Publication Data available on file.

ISBN: 978-1-62914-165-7

Printed in China

Audrey Hepburn

A PHOTOGRAPHIC CELEBRATION

edited by Suzanne Lander

Skyhorse Publishing

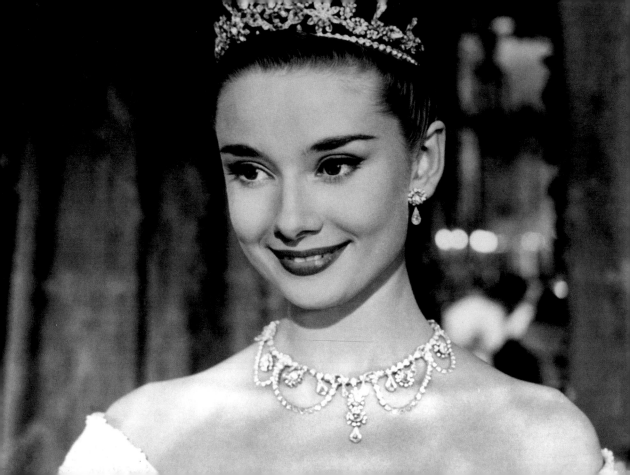

"You could *believe* her as a princess."
—WILLIAM WYLER, DIRECTOR
OF *ROMAN HOLIDAY* (1953)

"I can really take no credit for any talent that Audrey may have. If it's real talent, it's God-given. I might as well as be proud of a blue sky or the paintings in the Flemish exhibition at the Royal Academy."
—Baroness von Heemstra, on the success of her daughter

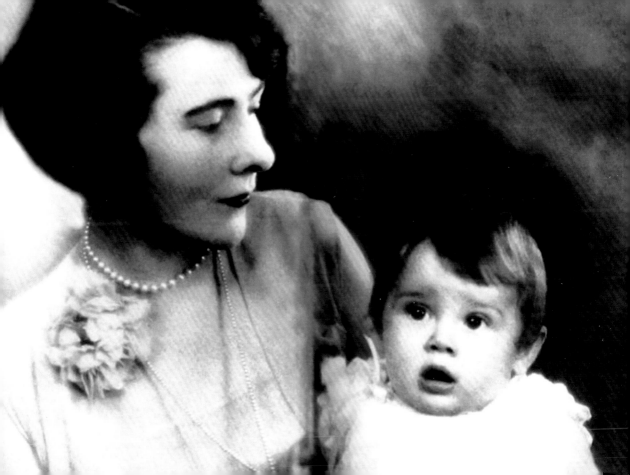

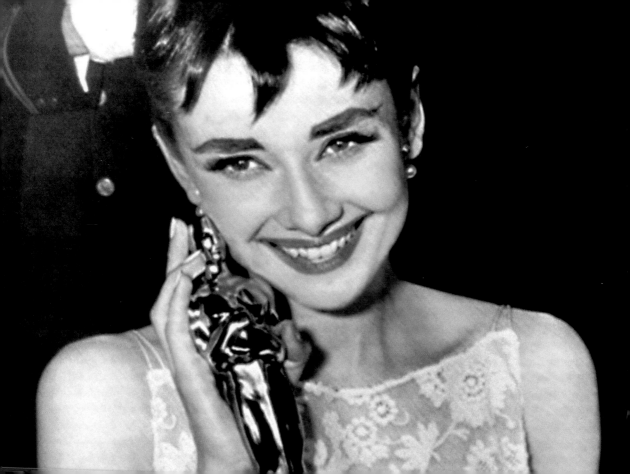

"My mother always used to say, 'Good things aren't supposed to just fall in your lap. God is very generous, but he expects you to do your part first.' So you have to make that effort. But at the end of a bad time or a huge effort, I've always had— how shall I say it?—the prize at the end."
—AUDREY HEPBURN

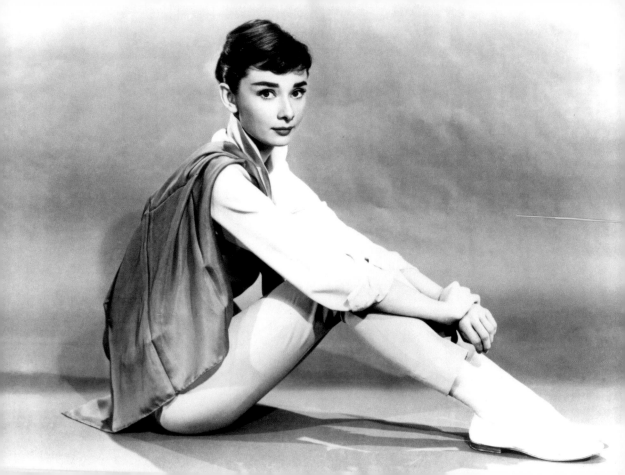

During World War II, Audrey danced in secret performances to raise money for the Dutch Resistance. She eventually had to stop dancing, though, because of malnourishment caused by a diet of mostly endive and tulip bulbs.

"This girl, single-handedly, may make bosoms a thing of the past."
—DIRECTOR BILLY WILDER

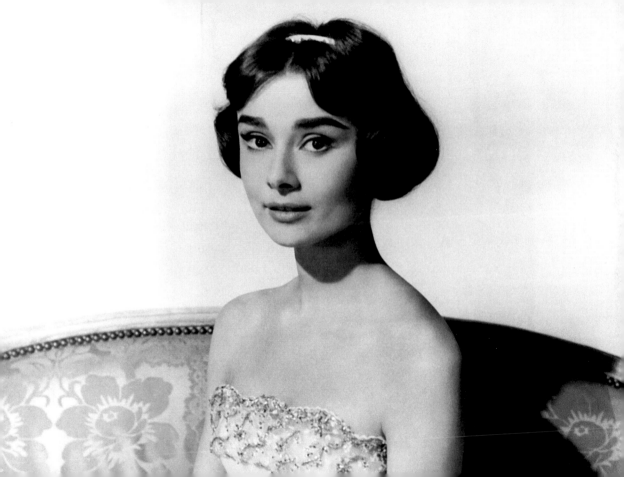

Offered the lead in the movie *Gigi* (1958), Hepburn turned it down to star in *Funny Face* (1957) instead. Thrilled that she would be putting all those years of dance training to good use, she asked for—and got—famed hoofer Fred Astaire.

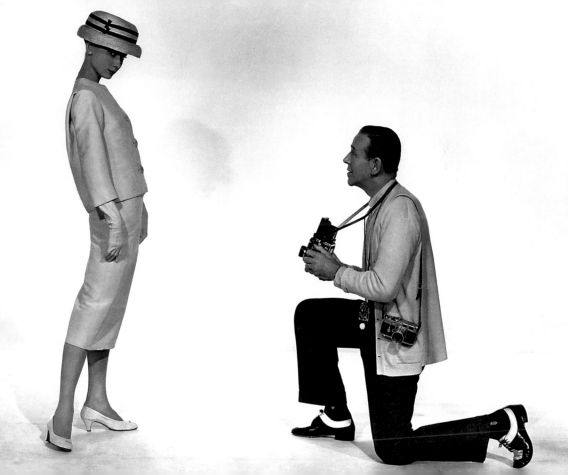

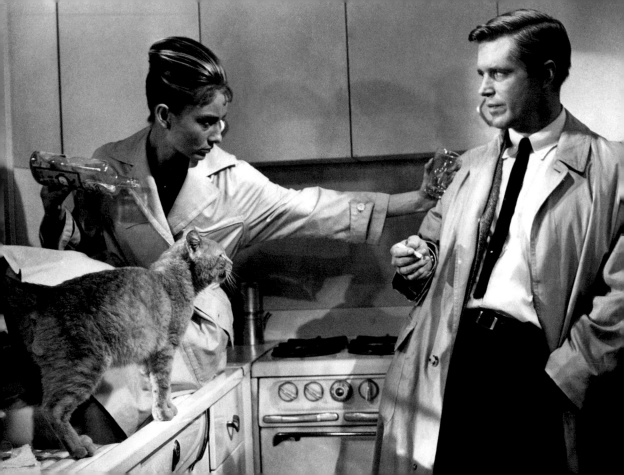

"Nothing really happened in the book. All we had was this glorious girl—a perfect part for Audrey Hepburn. What we had to do was devise a story, get a central romantic relationship, and make the hero a red-blooded heterosexual."
—George Axelrod, who adapted Truman Capote's *Breakfast at Tiffany's* (1961) for the screen

"I love Albie! Oh, I really do. He's so terribly, terribly funny. He makes me laugh like no one else can."
—Audrey, about Albert Finney, her costar in *Two for the Road* (1967)

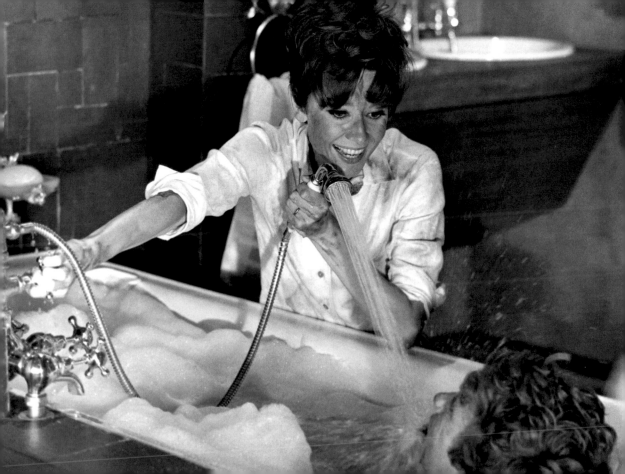

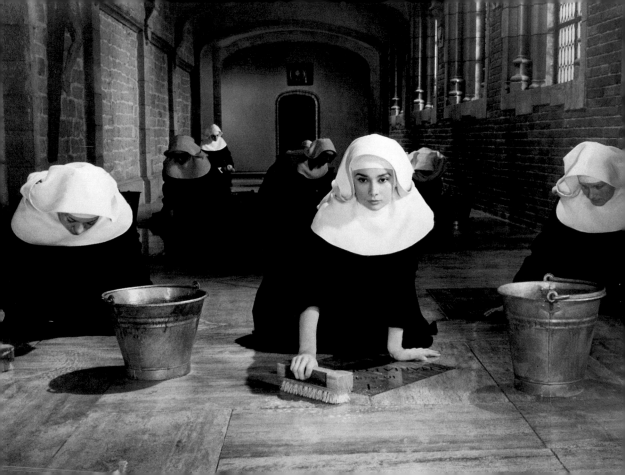

"I wish there were a half a dozen women like her . . ."
—FRED ZINNEMANN, DIRECTOR OF *THE NUN'S STORY* (1959)

To simulate blindness for her role in *Wait until Dark* (1967),
Audrey wore vision-blocking contact lenses.
She also learned to read Braille.

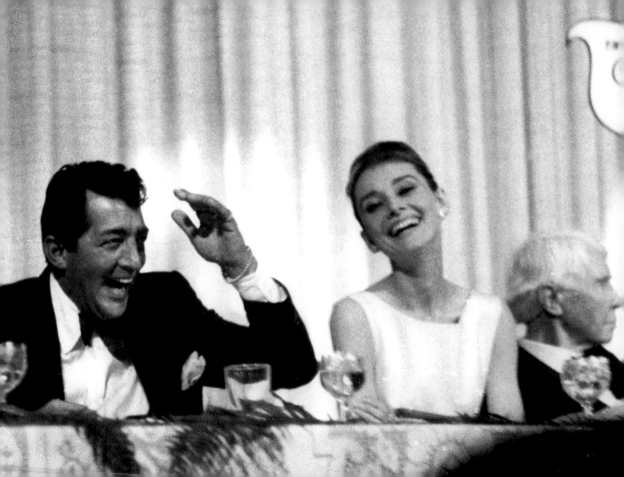

Dean Martin, Audrey, and poet Carl Sandburg make an
unlikely trio at a Friars Club banquet at the Beverly Hills Hotel
in the 1960s. In the 1954 Jerry Lewis & Dean Martin comedy
Living It Up, Martin did a scene in which he sang
a love song to a picture of Hepburn.

"One thing is certain. Audrey Hepburn is Natasha."
—KING VIDOR, DIRECTOR OF *WAR AND PEACE* (1956)

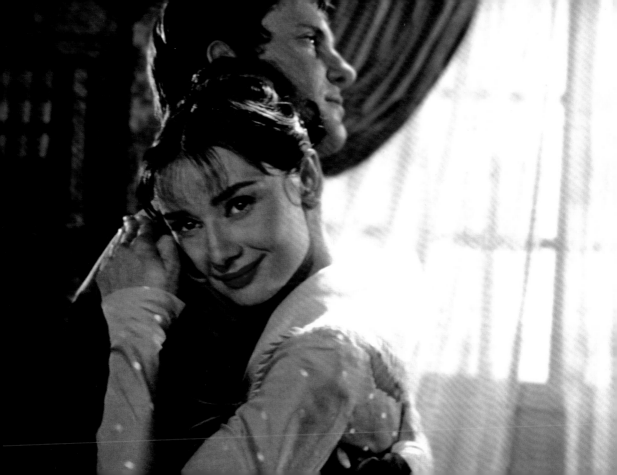

Paris When It Sizzles (1964), which reunited Audrey with former flame William Holden, was a remake of the 1952 French film *La Fête à Henriette (Holiday for Henrietta)*. The film did not do well. Judith Crist of the *New York Herald Tribune* dubbed it "Hollywood—when it fizzles."

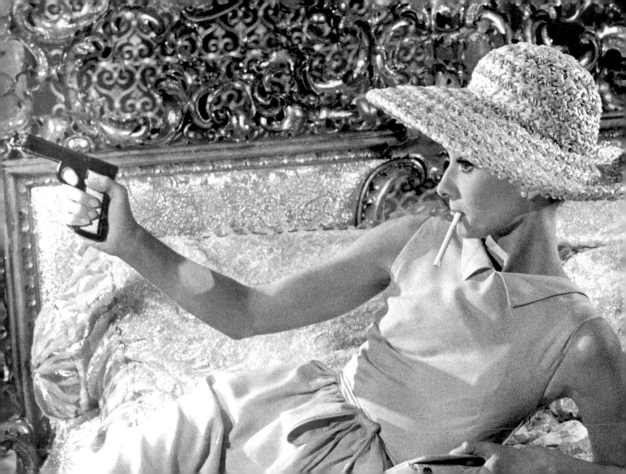

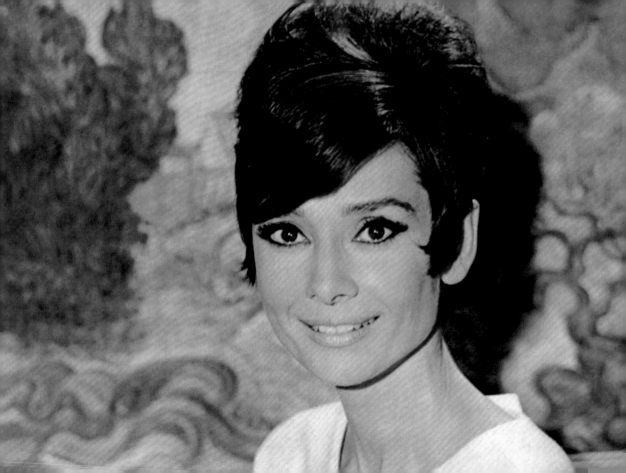

"Acting doesn't come easy to me. I put a tremendous amount of effort into every morsel that comes out."
—AUDREY HEPBURN, 1951

UNICEF appointed Audrey their Goodwill Ambassador in 1987.
A facility with language—she spoke Dutch, English, French,
Italian, and Spanish—was a great help with Hepburn's work
for the international organization.

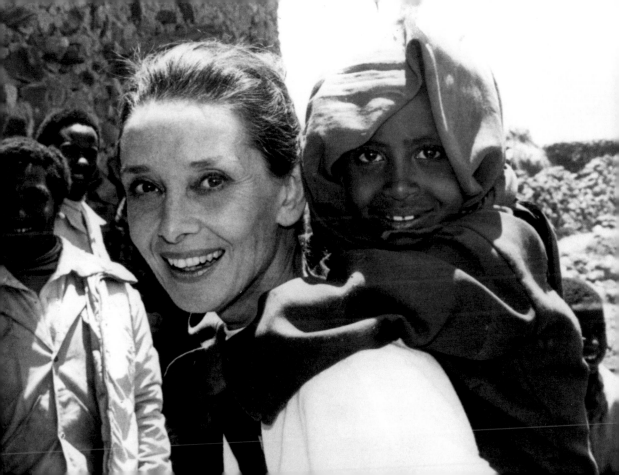

In the 1952 film *Secret People*, Audrey plays a ballerina prodigy. Since she had spent many years training for just this profession, she did all of her own dance sequences.

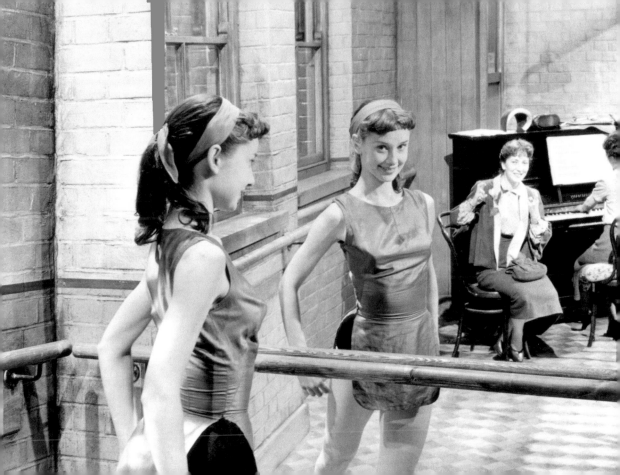

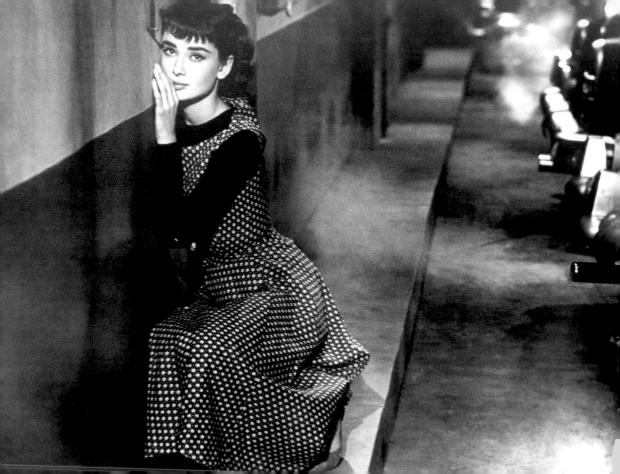

"P.S. Don't have David at the funeral.
He probably wouldn't even cry."
—POSTSCRIPT TO SABRINA'S SUICIDE NOTE

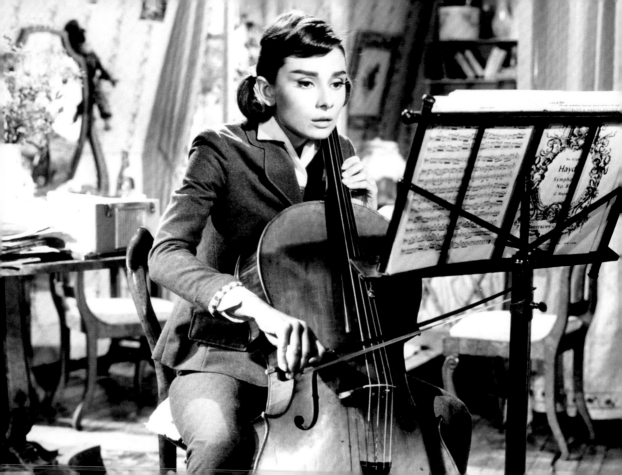

Love in the Afternoon (1957) features Hepburn as Ariane Chavasse, the naïve cello-playing daughter of a cynical private detective (Maurice Chevalier). While she is practicing Haydn, she cannot get the strains of the song "Fascination"—or the visage of playboy millionaire Frank Flanagan (Gary Cooper)—out of her mind.

John Huston's *The Unforgiven* (1960) was Hepburn's only Western. In between scenes, Audrey got thrown by a horse and broke her back. After spending six weeks in the hospital, she resumed acting in the film while wearing a back brace.

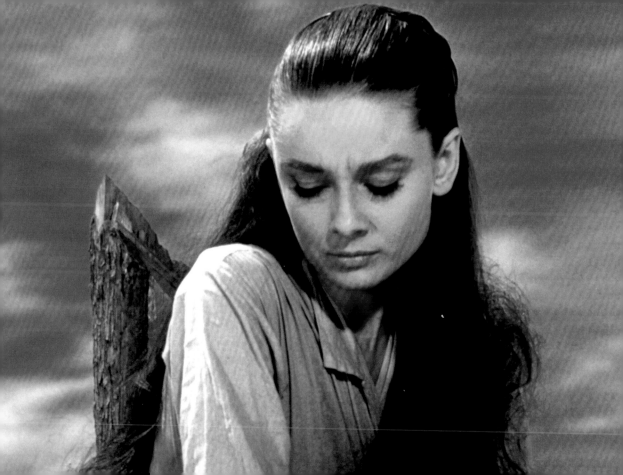

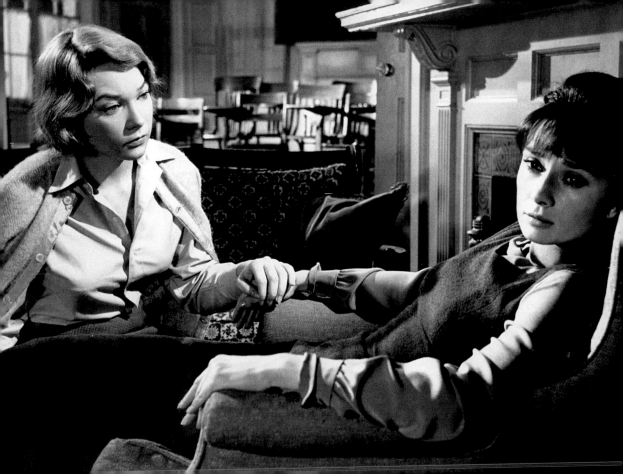

"She was supposed to teach me how to dress, and I was supposed to teach her how to cuss. Neither of us succeeded."
—SHIRLEY MACLAINE, AUDREY'S COSTAR
IN *THE CHILDREN'S HOUR* (1961)

Fred Astaire's character Dick Avery in *Funny Face*
was based on famed fashion photographer
Richard Avedon, who was responsible
for photographic images in the film.

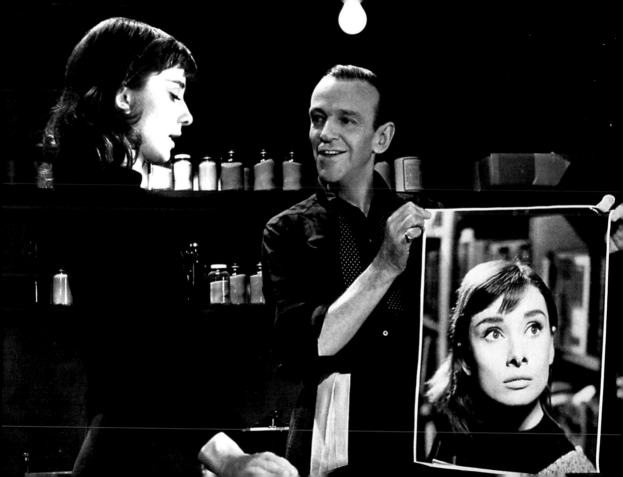

David: Sabrina, where have you been all my life?
Sabrina: Right above the garage.
—DIALOGUE FROM THE FILM *SABRINA* (1954)

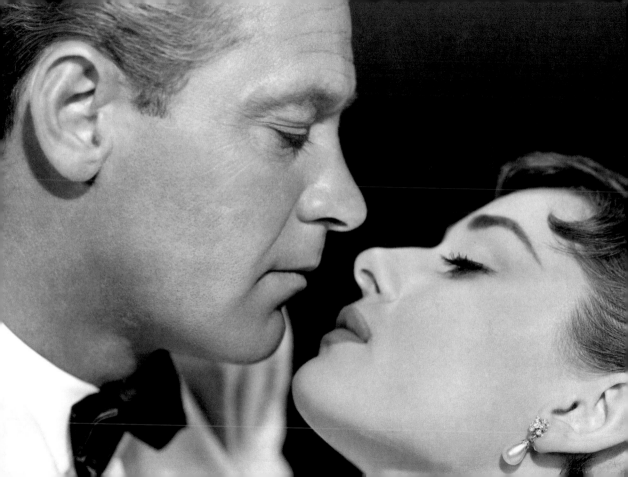

While filming *The Nun's Story* in the Congo, Audrey got bitten by a monkey. Since the bite wasn't serious, she didn't feel the need to worry her husband Mel Ferrer, who learned about it from a news story. The worried Ferrer spent the next twenty-four hours trying to get a phone call through to her.

Audrey credited her regal grace to growing up in England and Holland, countries that boasted their own princesses. Hepburn herself was the daughter of a baroness. Her mother's father, a baron who had held the post of governor of Surinam, had been a favorite of Holland's Queen Wihelmina.

"Audrey's extremely talented, and she learns with amazing speed."
—FRED ASTAIRE, HEPBURN'S COSTAR
IN *FUNNY FACE*

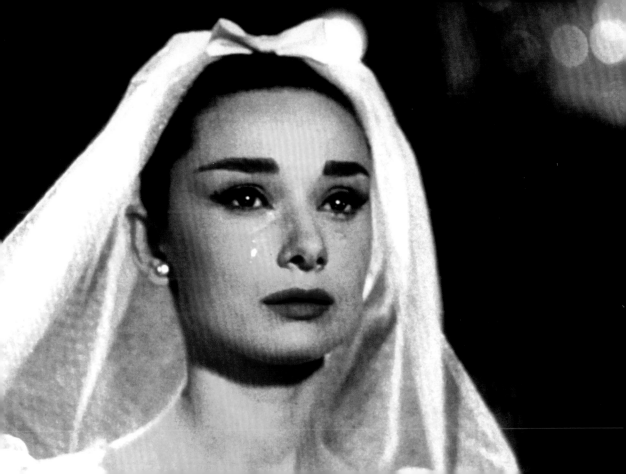

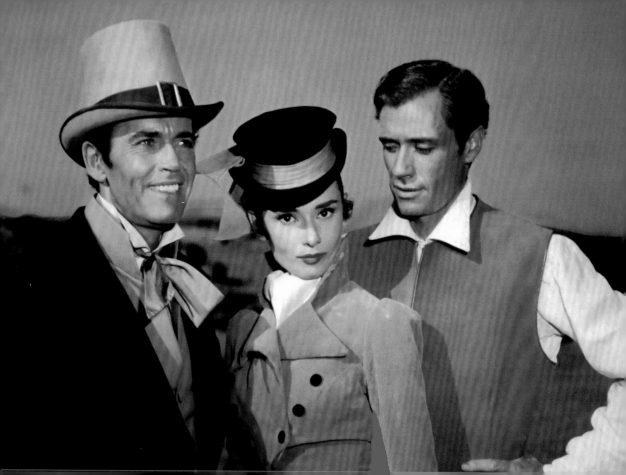

Audrey Hepburn (playing Natasha Rostov) costarred with
Henry Fonda (Pierre Bezukhov) and real-life
husband Mel Ferrer (Prince Andrei Bolkonsky)
in the costume drama *War and Peace*.

"What I've found does the most good is just to get into a taxi and go to Tiffany's. It calms me down right away, the quietness and the proud look of it . . ."
—AS HOLLY GOLIGHTLY IN *BREAKFAST AT TIFFANY'S*

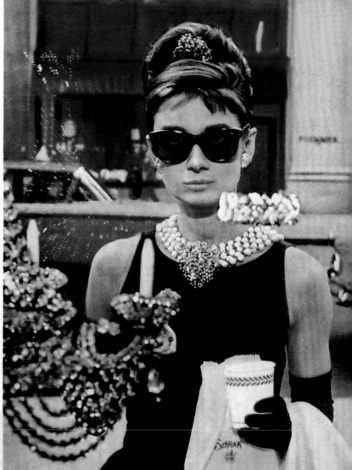

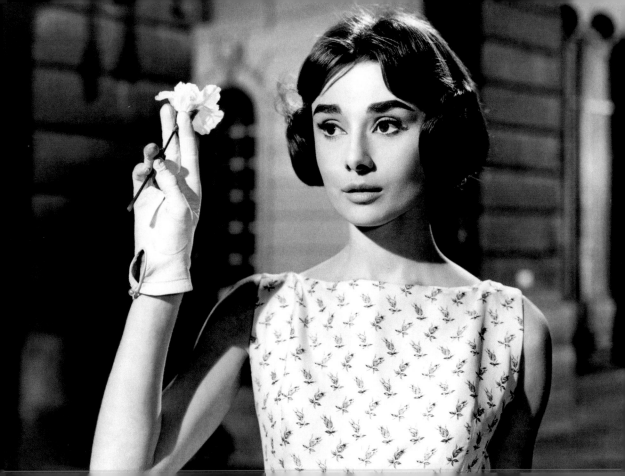

"Miss Hepburn is so winning in her youthful innocence and gaiety, so wistful when things go badly, that her impact on the jaded Cooper is easy to understand. Once again she will move her spectators to laugh and cry at almost the same time."
—WILLIAM K. ZINSSER, *NEW YORK HERALD TRIBUNE*, IN A REVIEW OF *LOVE IN THE AFTERNOON*

Monte Carlo Baby (1951) was shot at the same time as a French-language version, *Nous irons à Monte Carlo* (1952). Audrey was one of the only cast members to appear in both films. During the filming of this movie, Hepburn met famed novelist Colette, who recommended her for a stage version of her novel *Gigi*.

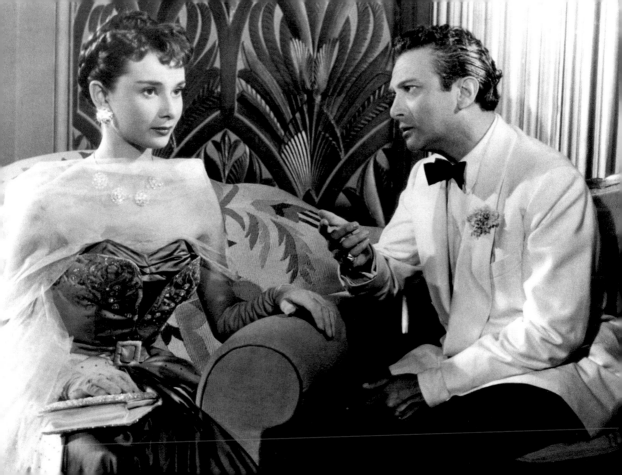

"Audrey is an extremely female female,
but she has the strength of steel
in that little sinewy body."
—CARY GRANT

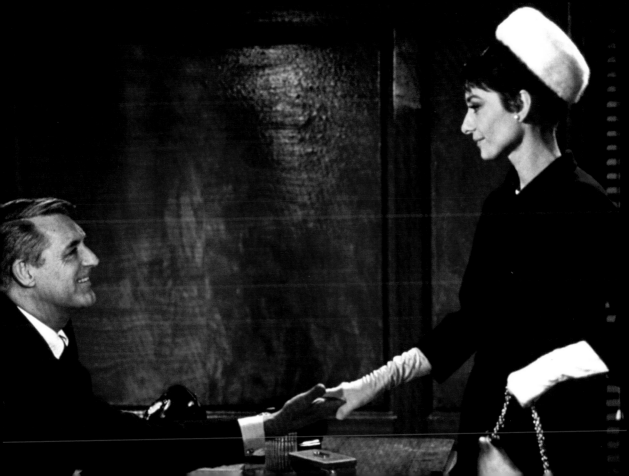

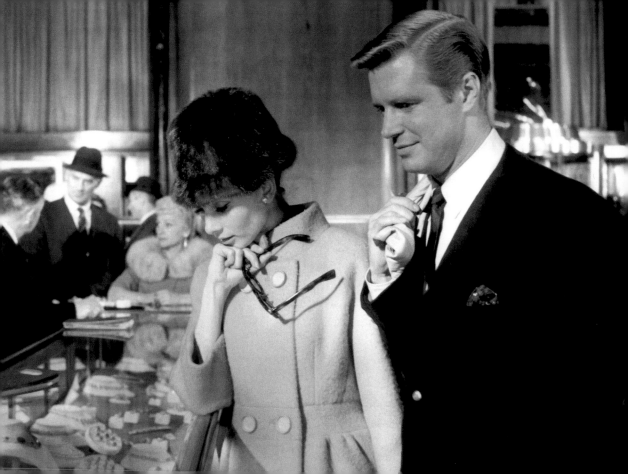

Much of *Breakfast at Tiffany's* was filmed on location
in New York City; Tiffany's, usually closed
for business on Sunday, opened its golden doors
on that day to accommodate the film crew
shooting scenes in the store's interior.

Though everybody else has an award, Audrey is still all smiles at the 1965 Academy Awards. When Audrey didn't get an Oscar nomination for her performance in *My Fair Lady* (1964), some devoted members of the Academy tried a write-in campaign. Public consensus was that the snub occurred because Marnie Nixon's singing voice was dubbed over Hepburn's for the vast majority of the musical numbers.

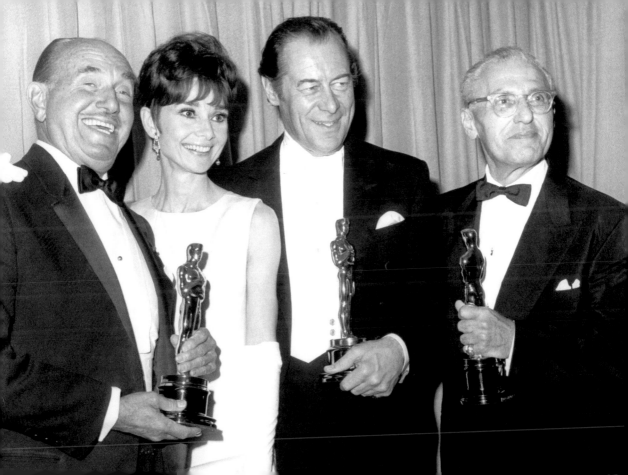

"You don't get nominated for being mean to Audrey Hepburn!"
—Alan Arkin, responding to why he didn't get
an Oscar nomination for his role as
the sinister Harry Roat in *Wait until Dark*

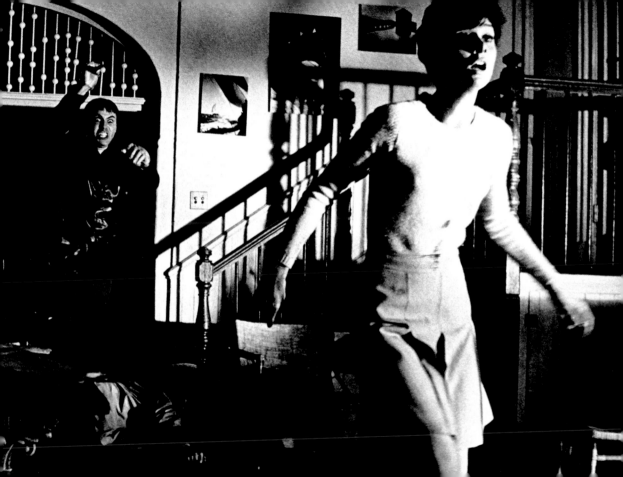

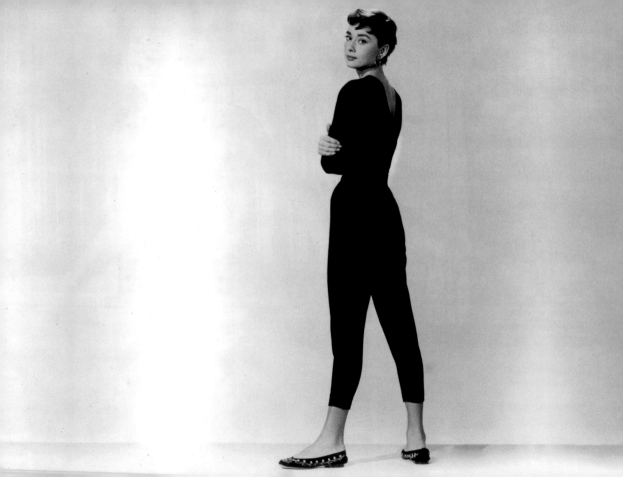

34A-20-34
—Hepburn's measurements in 1953,
according to *Celebrity Sleuth* magazine

"She is one of us."
—THE QUEEN MOTHER OVERHEARD SPEAKING
TO QUEEN ELIZABETH
AFTER BEING INTRODUCED TO AUDREY

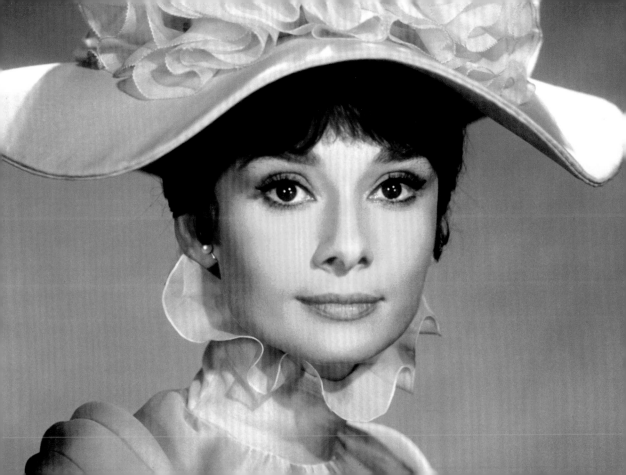

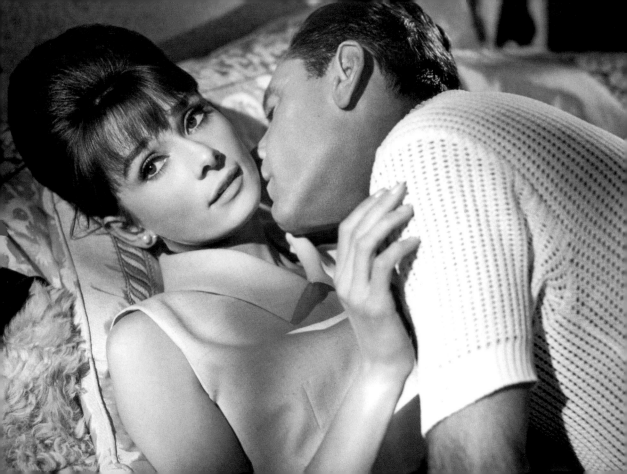

"Audrey tried to stay calm, cool, and collected,
but working with Bill was a torment for her."
—RICHARD QUINE, DIRECTOR OF *PARIS WHEN IT SIZZLES*,
ABOUT HEPBURN'S RELATIONSHIP WITH
FORMER FLAME WILLIAM HOLDEN

Before Hepburn and MacLaine signed on, the other
Hepburn—Katharine—and Doris Day were considered
for the roles of the schoolteachers in the remake
of Lillian Hellman's *The Children's Hour*.

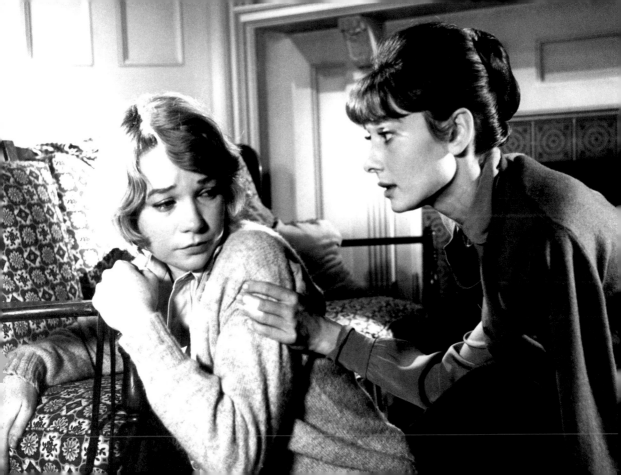

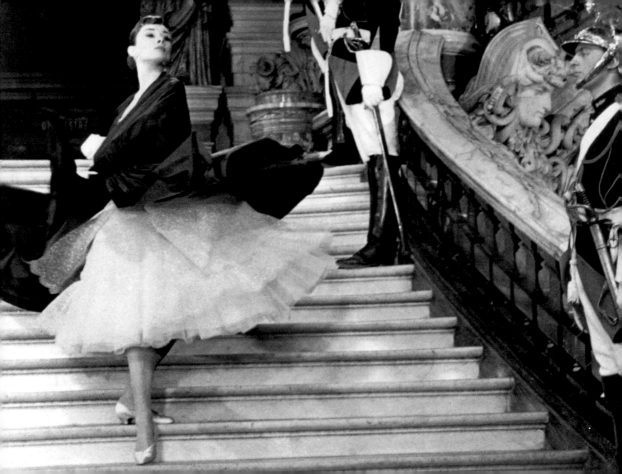

At Hepburn's insistence, Paramount hired Givenchy to design the leading lady's wardrobe for *Funny Face*, which really irked costumer Edith Head despite the fact that she had gotten screen credit for Givenchy's gown worn by Audrey in *Sabrina*.

"'Moon River' was written for her. No one else had ever understood it so completely. There have been more than a thousand versions of 'Moon River,' but hers is unquestionably the greatest."
—HENRY MANCINI

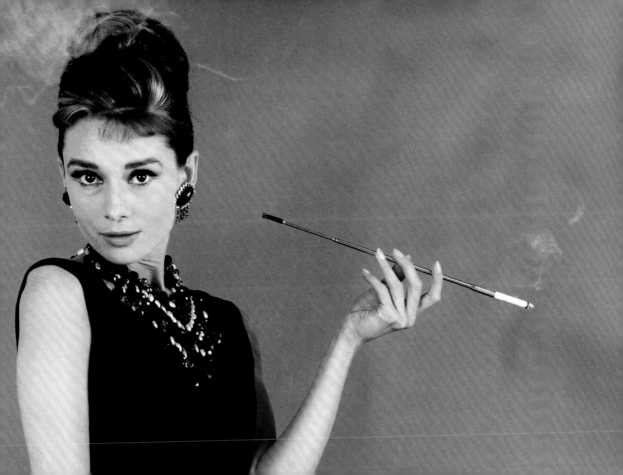

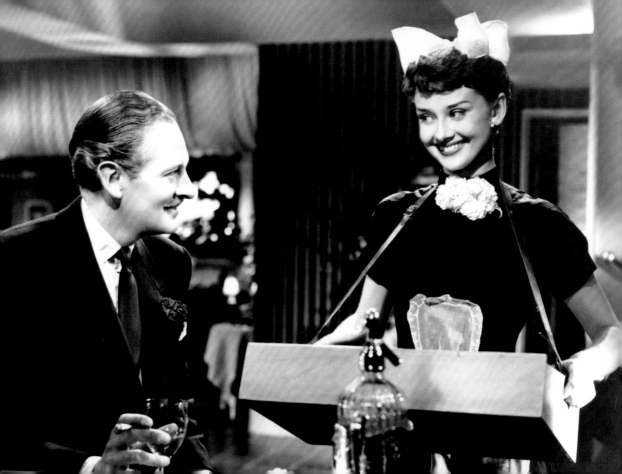

Audrey played a bit part as a cigarette girl in the 1951 British film *Laughter in Paradise*. She was originally selected for a larger role, but her stage obligations didn't allow for that sort of time commitment.

"A woman happily in love, she burns the soufflé.
A woman unhappily in love,
she forgets to turn on the oven."
—Baron St. Fontanel in *Sabrina*

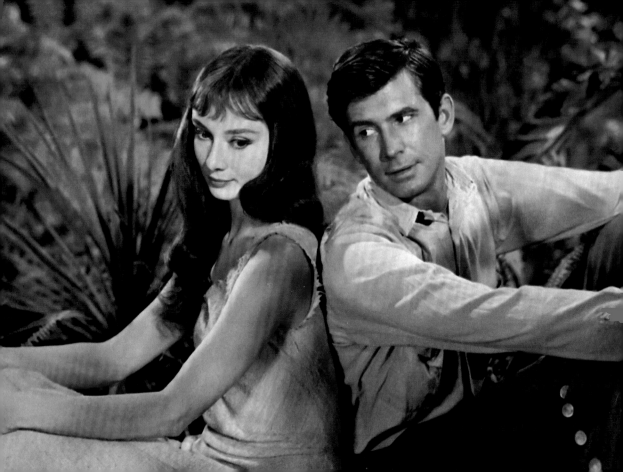

Audrey turned down the title role in *The Diary of Anne Frank* to appear in *Green Mansions* (1959), the first major Hollywood film to be shot in the wide-screen format called Panavision. Though still youthful looking, she considered herself too old (at thirty) to play a fifteen-year-old.

In 1962, husband Mel Ferrer was keen on Audrey
to star as Peter Pan in a live-action version of the film,
with Peter Sellers as Captain Hook and Hayley Mills
as Wendy, but the project fell through.

William Wyler's third picture with Hepburn, *How to Steal a Million* (1966), started out being called *Venus Rising* and then was changed to *How to Steal a Million Dollars and Live Happily Ever After* before the title was mercifully shortened.

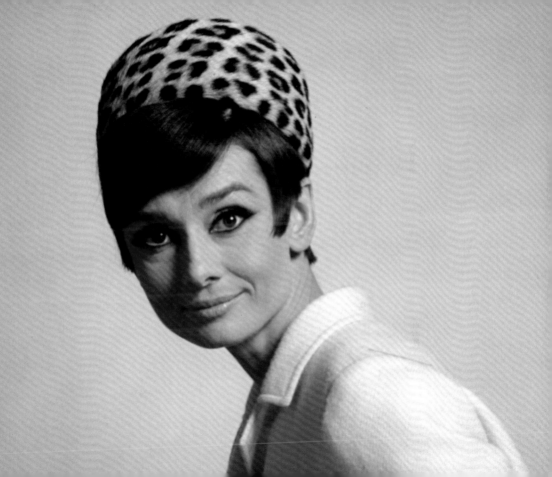

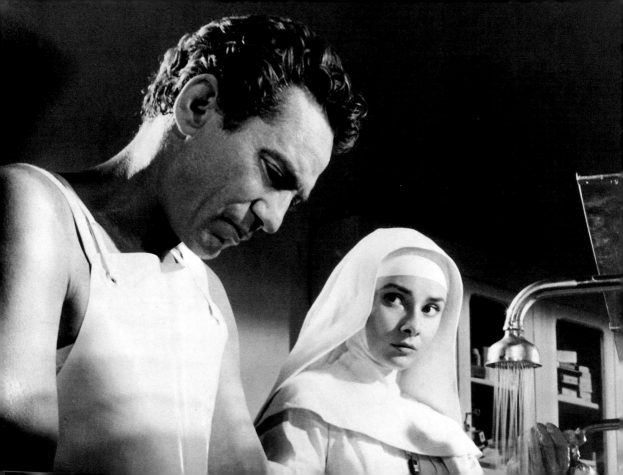

"Chaleur torride, mais suis heureuse.
[Torrid heat, but am happy]"
—A TELEGRAM SENT BY AUDREY TO HER HUSBAND
WHEN SHE ARRIVED IN THE CONGO
FOR THE FILMING OF *THE NUN'S STORY*

"Audrey had that rare thing—audience authority—
that makes everybody look at you."
—CATHLEEN NESBITT, WHO PLAYED GREAT-AUNT ALICIA
IN THE STAGE PRODUCTION OF *GIGI*

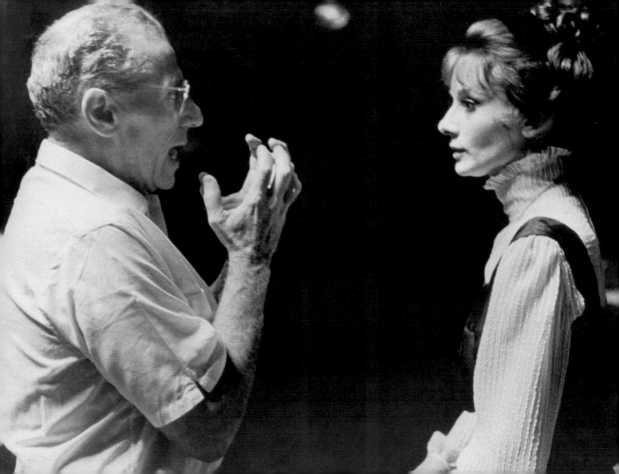

While George Cukor had to turn down directing her in *Gigi*,
due to other obligations, he did direct Audrey
more than a decade later in *My Fair Lady*.

"I knew the time had come to quit when one critic said of *Funny Face* that it had 'something old, something new.'"
—FRED ASTAIRE, AUDREY'S COSTAR IN *FUNNY FACE*

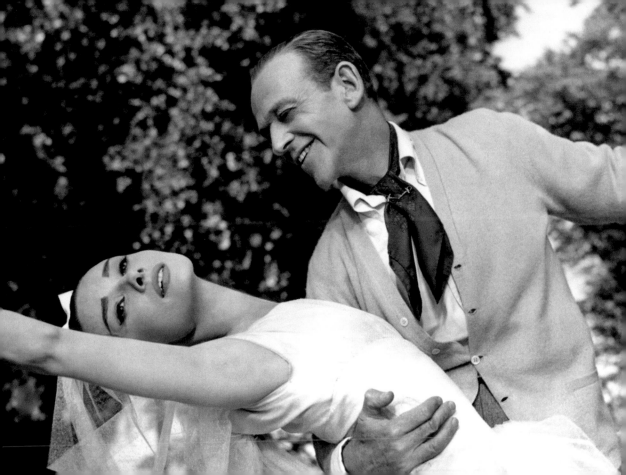

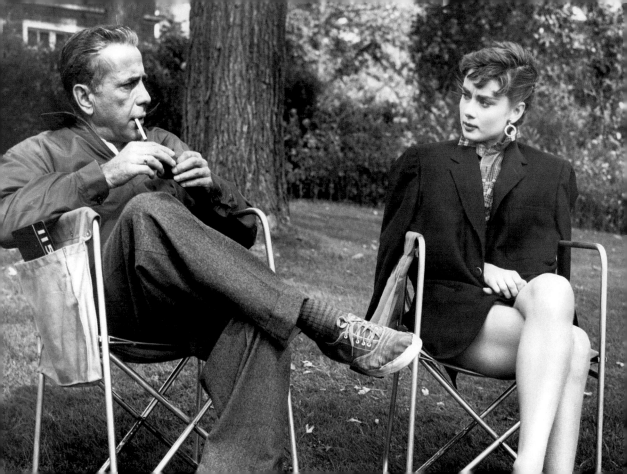

"Audrey is like a good tennis player.
She is unpredictable, interesting,
and varies her shots."
—HUMPHREY BOGART, DURING
THE FILMING OF *SABRINA*

In *Two for the Road* (1967), the couple played by Audrey and Albert Finney struggle through the ups and downs of romance and marriage. The movie reflected Audrey's own troubled twelve-year union to Mel Ferrer.

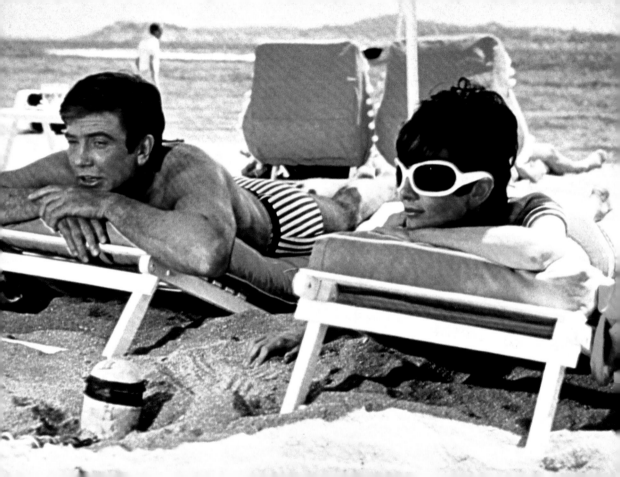

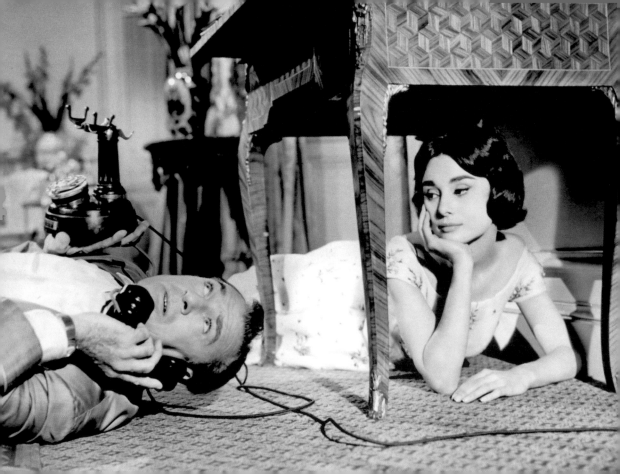

"I've been in pictures over thirty years, but I've never had a more exciting leading lady than Audrey."
—GARY COOPER, HEPBURN'S COSTAR
IN *LOVE IN THE AFTERNOON*

Marilyn Monroe was originally cast as Holly Golightly,
but she backed out, and the sophisticated and
elegant Audrey Hepburn got the role,
which suited her to a T, as in tiara.

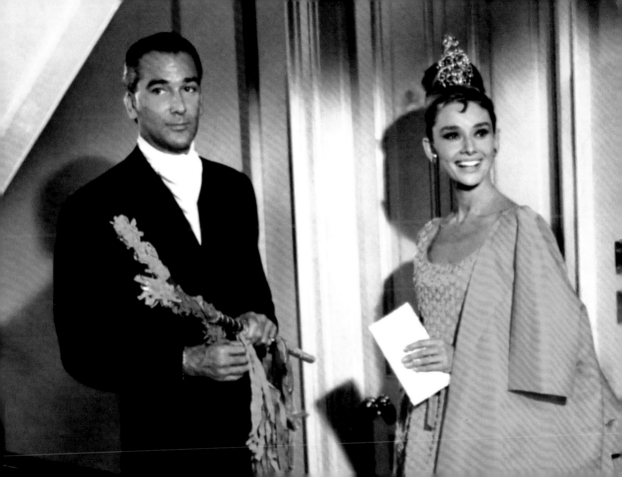

"Mel Ferrer!"
—AUDREY'S RESPONSE TO THE QUESTION
"WHO IS YOUR FAVORITE ACTOR?"
IN AN INTERVIEW IN AN OCTOBER
1966 *COSMOPOLITAN* INTERVIEW

When films were shot on location, city
institutions could be very accommodating.
The crew took over Paris's Louvre Museum in its
off hours to film this scene from *Funny Face*.

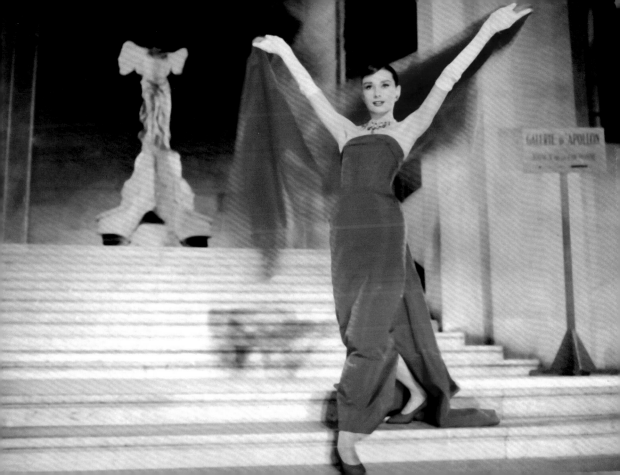

For *Charade* (1963), Givenchy created nineteen different outfits for Audrey. She wore the designer's couture both on and off the screen, and Interdit Perfume was created by him especially for her.

"Soon you will see one of the world's most exciting and exotic stories . . . Young lovers in a jungle Eden where menace lurks amid the orchids!"

—FROM THE AD FOR *GREEN MANSIONS*

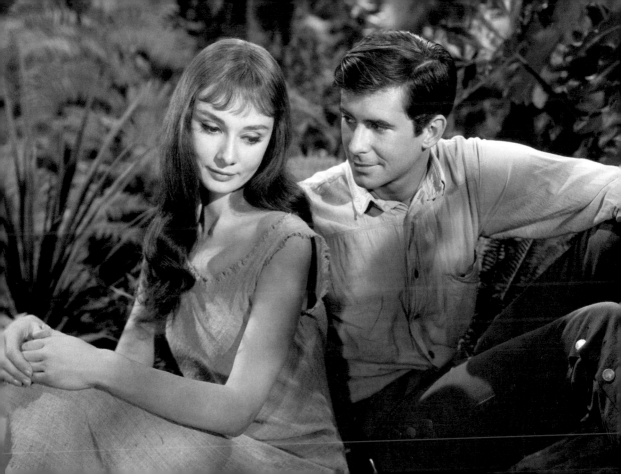

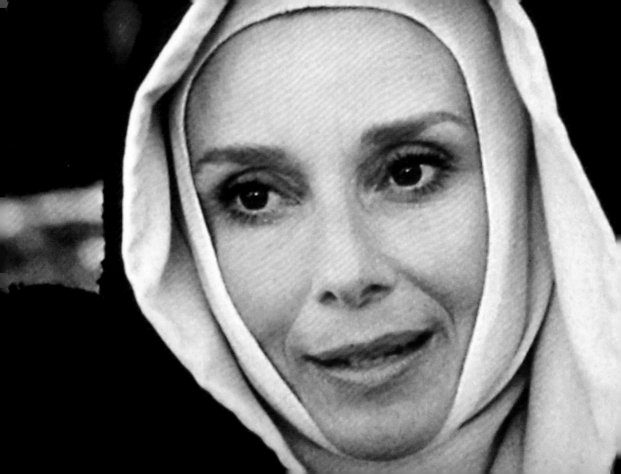

Audrey portrayed a nun twice—once in her Oscar-nominated performance as Sister Luke in *The Nun's Story*, and again as a mother superior formerly known as Maid Marian in *Robin and Marian* (1976). Her sons, who adored Sean Connery in his James Bond role, insisted that she take the part.

"We couldn't have made *Charade* anywhere else. Fifty percent of the picture took place in the Paris streets. It would have been impossible to build that many exterior sets in Hollywood and still have the production solvent."
—Cary Grant

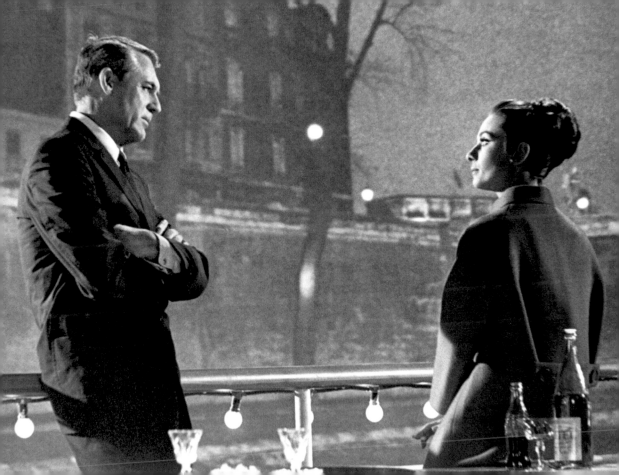

Hepburn costarred with Robert Wagner in *Love Among Thieves* (1987), her last feature-length film. While an adoring audience gave the TV movie high ratings, critics were less kind about the material, deeming the script "uninspired."

Green Mansion makeup artist William Tuttle shows Audrey the somewhat naturalistic look (by Hollywood standards) for jungle girl Rima to complement MGM hairstylist Sidney Guilaroff's plan for the character's long flowing hair and feathery bangs.

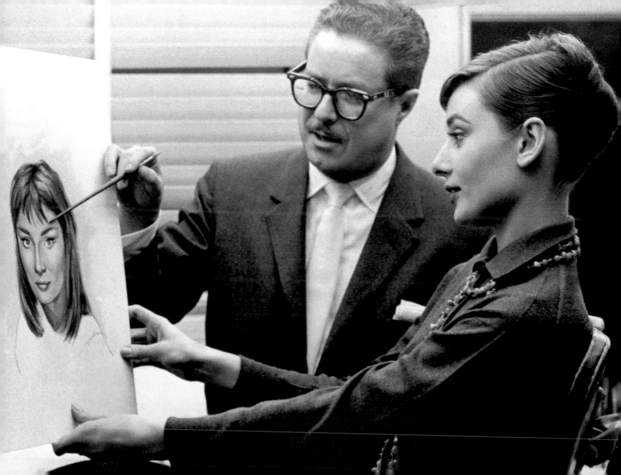

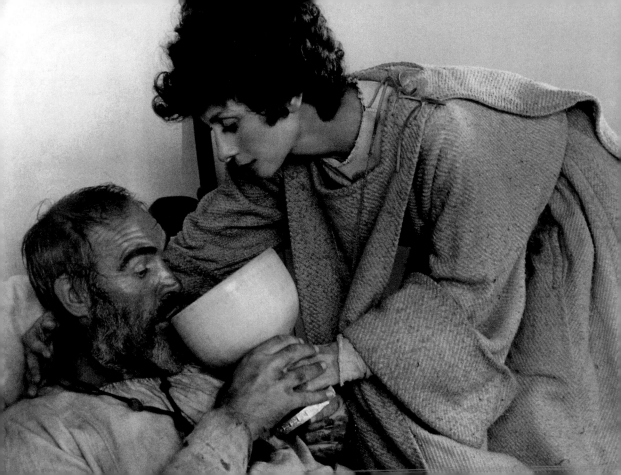

Audrey didn't enlist Givenchy to do her wardrobe
for *Robin and Marian*, as her various costumes
were composed of sackcloth, based
on original attire of the period.

In 2002, *Sabrina* became one of twenty-five films
selected for the National Film Registry.
To qualify, a movie must be at least
ten years old and "be culturally, historically,
or aesthetically significant."

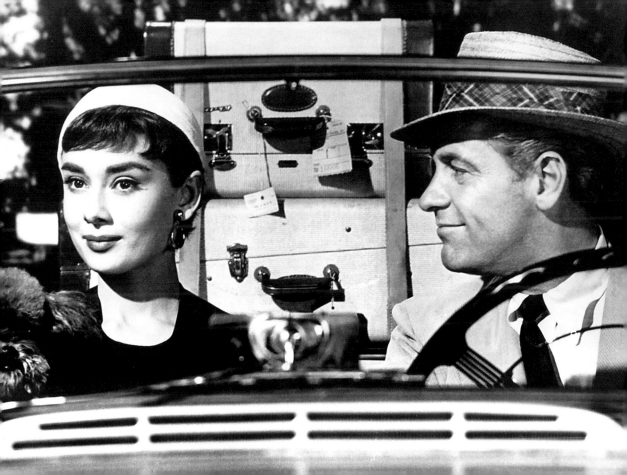

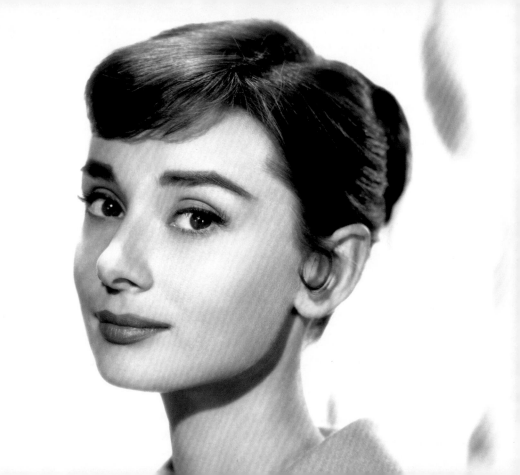

"She seemed so terribly . . . different,
and so very angelic
and so very ethereal—
like some sort of fairytale person."
—HARRY BELAFONTE

"I don't know of anyone in the rest of the world—with the possible exception of Audrey Hepburn—who in bare feet and rags . . . could give an impression so regal and dignified."
—MORITZ THOMSEN, FROM *LIVING POOR: A PEACE CORPS CHRONICLE,* 1970

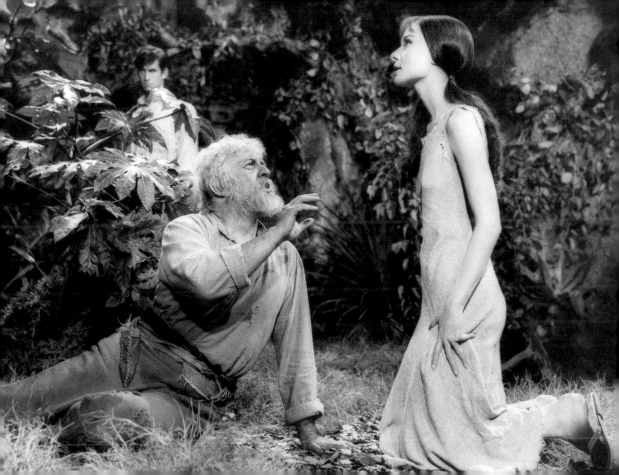

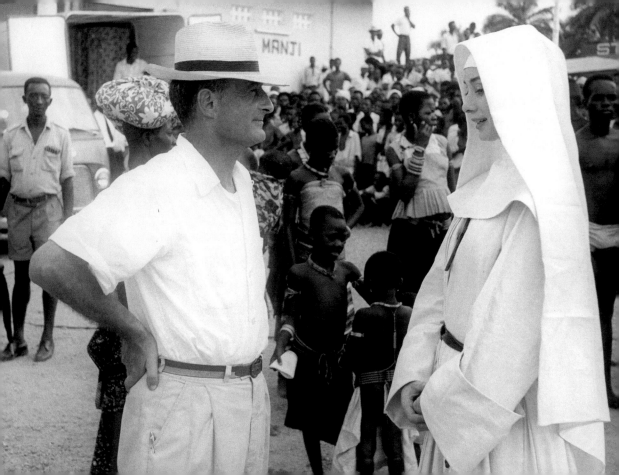

The local Congo inhabitants were confused by why Audrey, clothed for the role of Sister Luke in *The Nun's Story*, was driven around by a chauffeur and changed into "civilian" clothes at the end of the day. Audrey didn't speak the native language to explain, so her driver told them: "She is a queen of a far-away country called Warner Brothers." This didn't clarify the nun part, so he added: "The queen of Warner Brothers happens to be a nun."

"I'd like to be played as a child by Natalie Wood.
I'd have some romantic scenes as Audrey Hepburn and have
gritty black-and-white scenes as Patricia Neal."
—GLORIA STEINEM

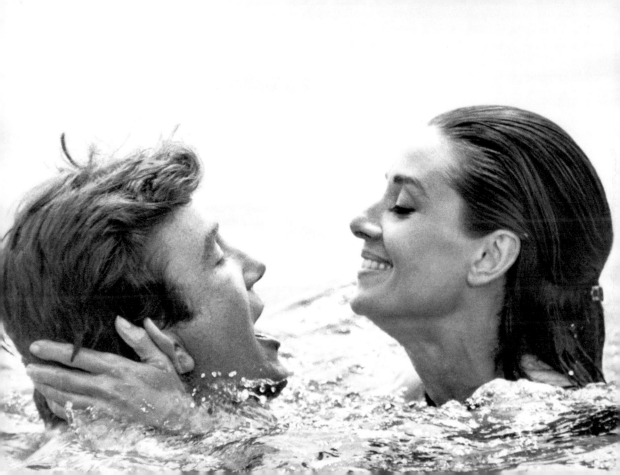

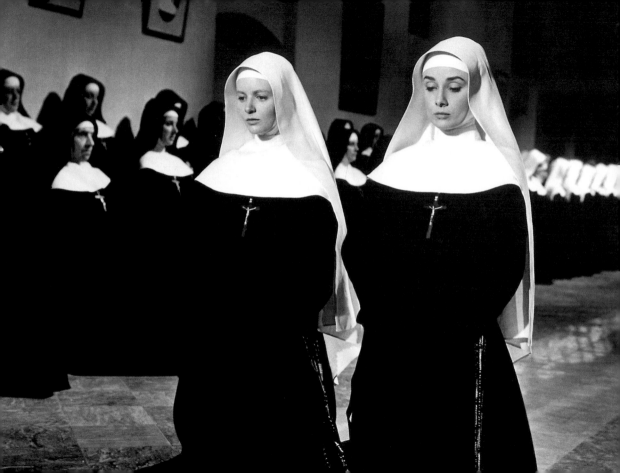

Ingrid Bergman had been offered the role of Sister Luke
in *The Nun's Story* but turned it down because
she considered herself too old for the part,
instead suggesting Audrey Hepburn. Hepburn received
an Oscar nomination for her portrayal
in the dramatization of the real nun's life.

"Just nonsense. I don't want to be ungallant, but Audrey's too old and wrinkled for me."
—GROUCHO MARX, 1952, ABOUT GOSSIP THAT HEPBURN AND HE WERE ENGAGED

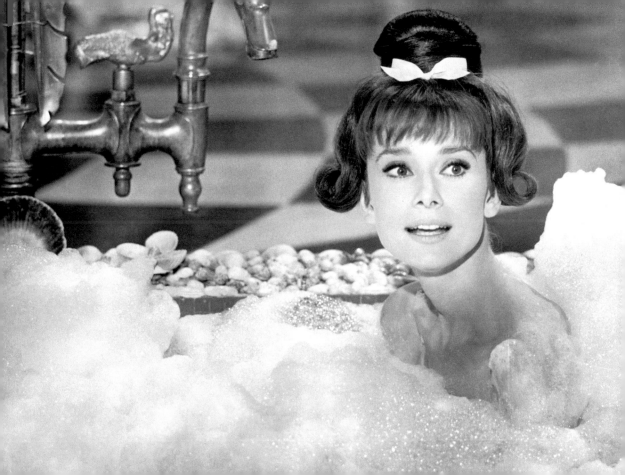

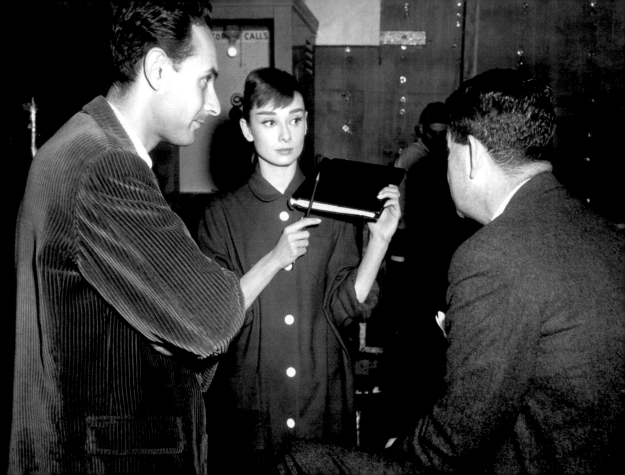

Director Stanley Donen and Audrey Hepburn worked well together and made three very successful films—*Funny Face* (1957), *Charade* (1963), and *Two for the Road* (1967).

"When I finally say I love you to any man and really mean it, it will be like a defeated general who's lost all his troops, surrendering and handing his sword to the enemy."
—AUDREY HEPBURN AS NATASHA IN *WAR AND PEACE*

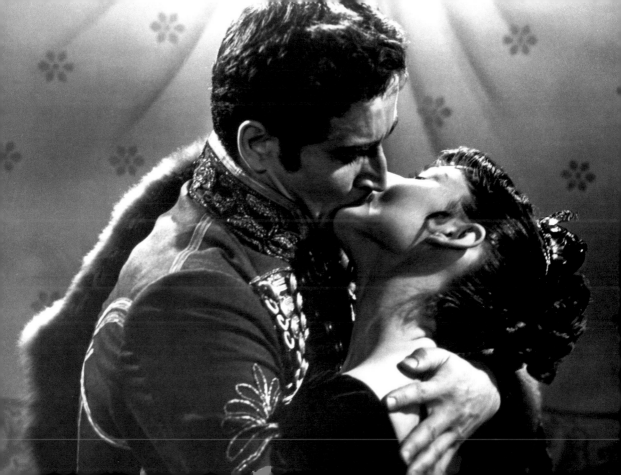

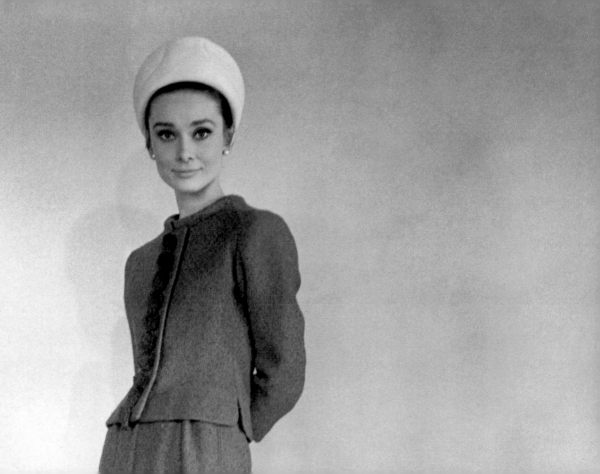

"She has the ideal face and figure, with her long, slim body and swanlike neck. It's a real pleasure to make clothes for her."
—HERBERT DE GIVENCHY

Audrey and William Holden both owed Paramount Pictures one movie to fulfill their contracts, so the movie company whipped up a confection called *Paris When It Sizzles*, adapted from a French farce by *Breakfast at Tiffany's* George Axelrod. Though filmed in 1962, it was not released until 1964, and neither the public nor critics were very complimentary about the film; Stanley Kauffmann, in *New Republic*, wrote "Contributions are in order from admirers of Audrey Hepburn to buy and suppress all copies of *Paris When It Sizzles*."

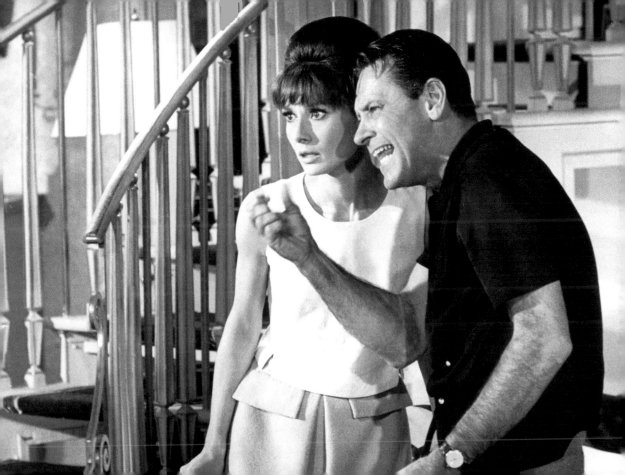

"I would say I'm a spirit more than anything.
But not an extraterrestrial. No, it's just
plain old me with a sweater on."
—HEPBURN, DESCRIBING HER ROLE AS HAP
IN STEVEN SPIELBERG'S *ALWAYS* (1989)

In *Two for the Road*, Audrey wore off-the-rack items
from Paris rather than couture by Givenchy.
This might have helped bring prêt-à-porter
to the eye of the American public.

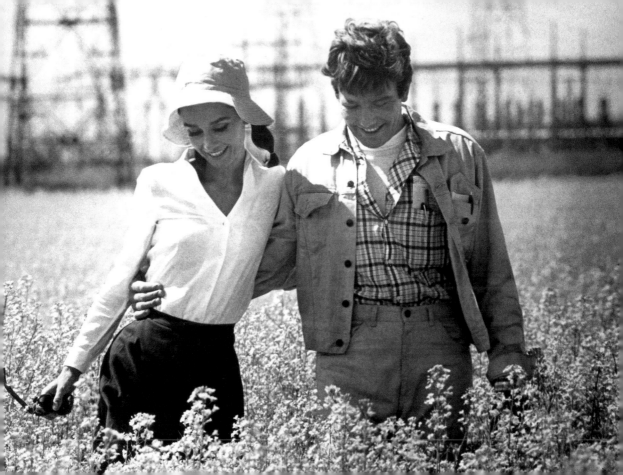

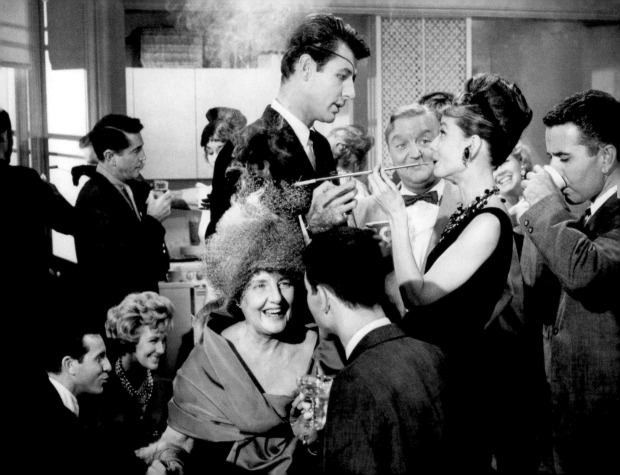

"But I am mad about José. I honestly think I would give up smoking if he asked me."
—AUDREY AS HOLLY GOLIGHTLY
IN *BREAKFAST AT TIFFANY'S*

After production of *Roman Holiday* was completed, the studio presented Audrey with her wardrobe from the film, including her shoes, handbags, hats, and jewelry.

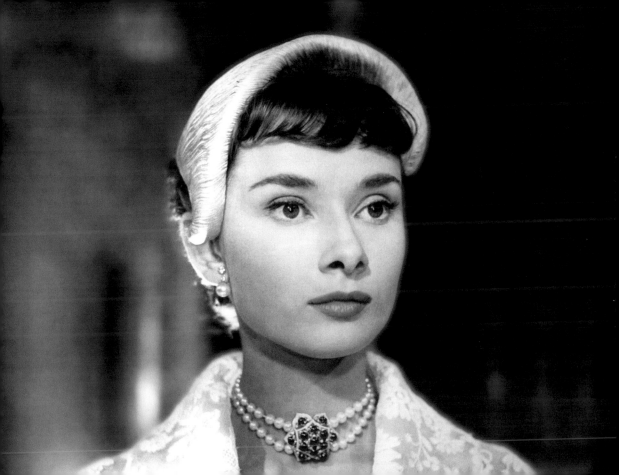

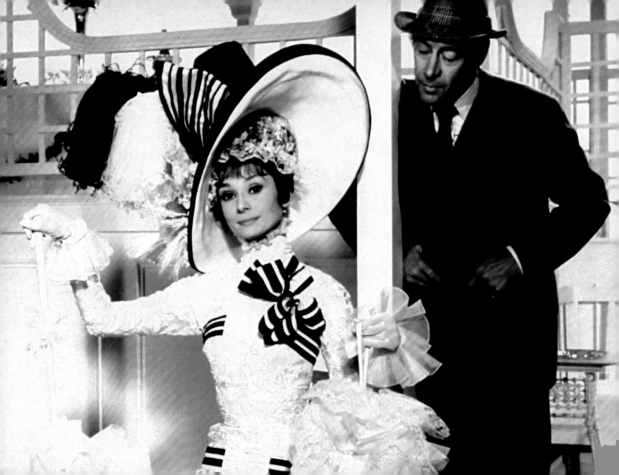

"I wanted to play Eliza more than anything in
the world, but I'm glad it's all over now.
It took everything I had."
—AUDREY HEPBURN, AFTER COMPLETION
OF *MY FAIR LADY*

Cary Grant had been offered the Humphrey Bogart role in *Sabrina* but turned it down because (born in 1904) he considered himself too old to play opposite Audrey Hepburn. Bogart, five years older than Grant, didn't consider the age gap of great concern.

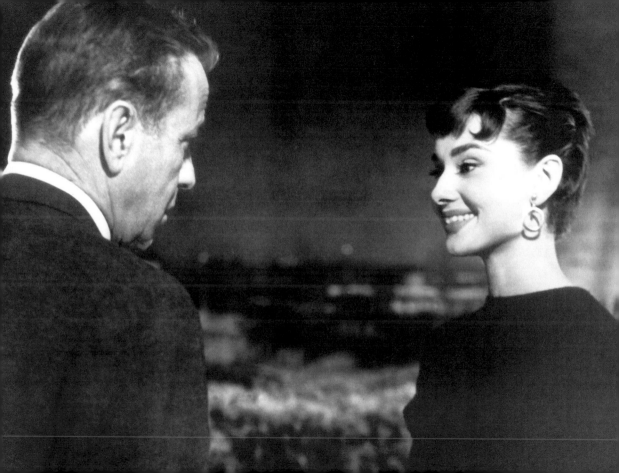

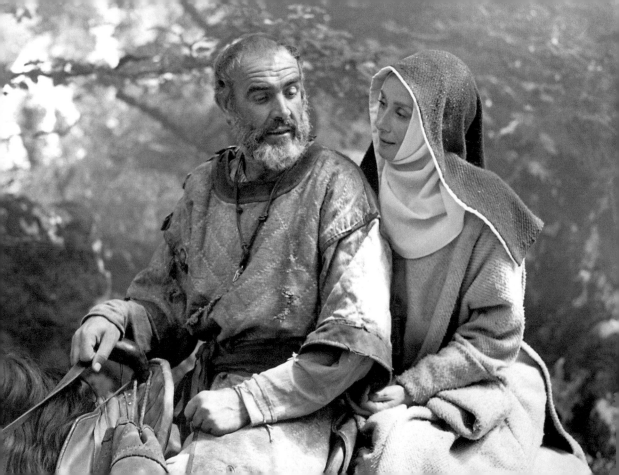

"Audrey Hepburn, possibly the only woman around who can make nun's habit look adorable."
—HOWARD KISSEL, *WOMEN'S WEAR DAILY*, ABOUT AUDREY'S SECOND OUTING AS A NUN, IN *ROBIN AND MARIAN*

Holly Golightly's living-room sofa was created
from a claw-foot bathtub cut lengthwise.
Note the faucets on one end.

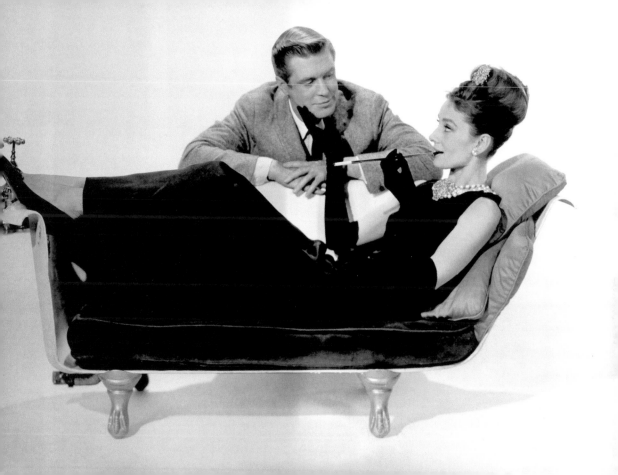

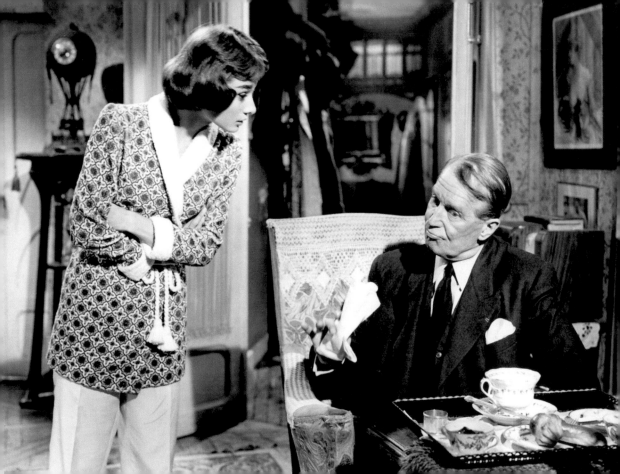

"How proud I would be, and full of love I would be,
if I really had a daughter like you."
—TELEGRAM TO AUDREY FROM MAURICE CHEVALIER ON THE
FIRST DAY OF FILMING *LOVE IN THE AFTERNOON*,
IN WHICH SHE PLAYED HIS DAUGHTER

Roman Holiday was the first American film to be shot entirely in Italy. The movie was shot in black-and-white so that the scenery didn't overwhelm the viewer and detract from the actors.

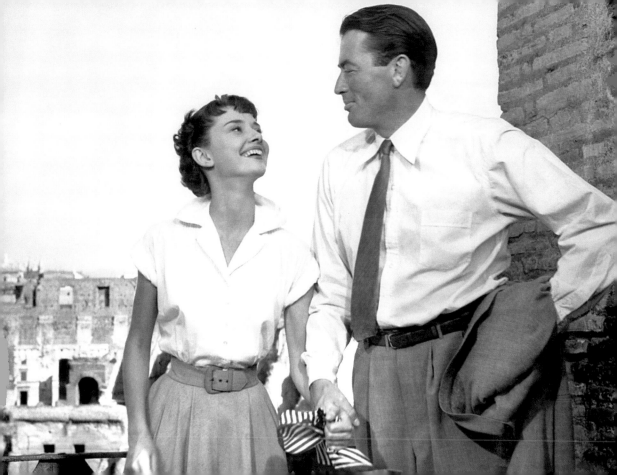

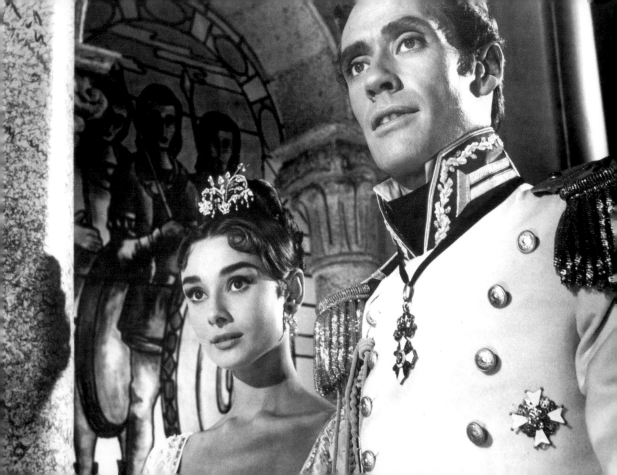

"I'm not worth it. It's impossible. Please don't tell anyone."
—AUDREY HEPBURN TO HER AGENT AFTER LEARNING
THAT HER $350,000 SALARY FOR *WAR AND PEACE*
WAS A RECORD HIGH FOR AN ACTRESS

Audrey's costar in *The Unforgiven*, screen veteran Lillian Gish proved herself an expert marksman, having learned to shoot from an ex-bank robber early in her career. In fact, she was a better shot than either director John Huston or costar Burt Lancaster, who offered to teach her.

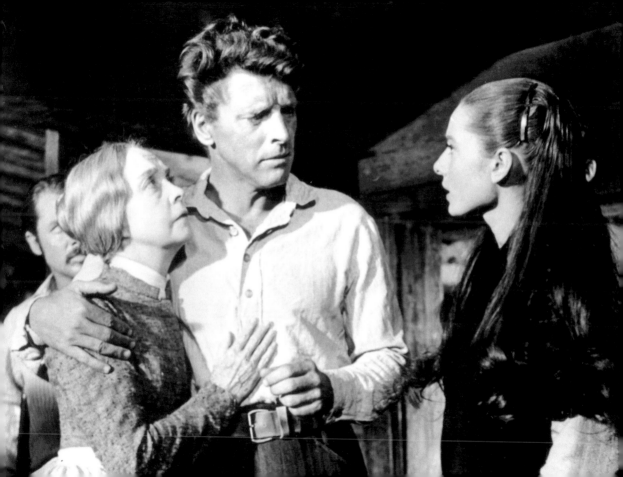

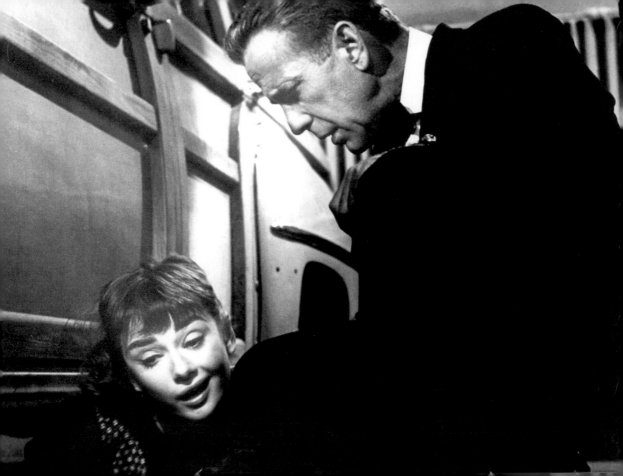

For *Sabrina*, director Billy Wilder once asked Hepburn
to feign illness so that he could continue working
on a script segment and not film it as it was.
Audrey complied.

While the movie never explains why Holly is wearing
a toga-like towel ensemble at a fête in her apartment,
a part of *Breakfast at Tiffany's* that ended up
on the cutting-room floor showed her taking a
bath when she remembers that she had
invited people over for a party.

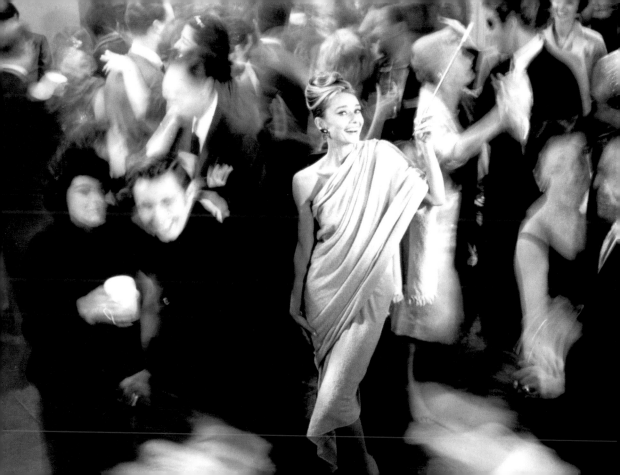

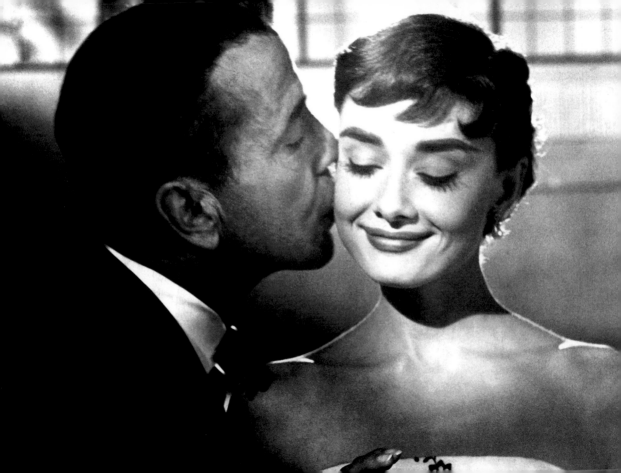

"I know I have more sex appeal on the tip of my nose than many women have in their whole bodies."
—AUDREY HEPBURN

"I must say that Audrey will be the ideal daughter-in-law.
She is such a delicious person, a dream.
The age difference doesn't matter."
—Signora Paola Roberti Bandini, Andrea Dotti's mother,
about her thirty-year-old son's upcoming marriage to
thirty-nine-year-old Audrey

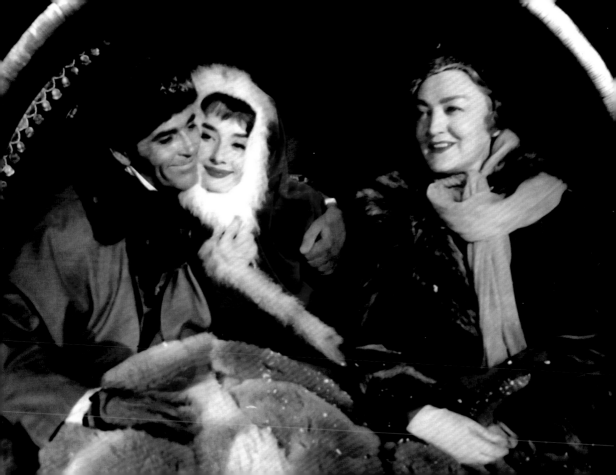

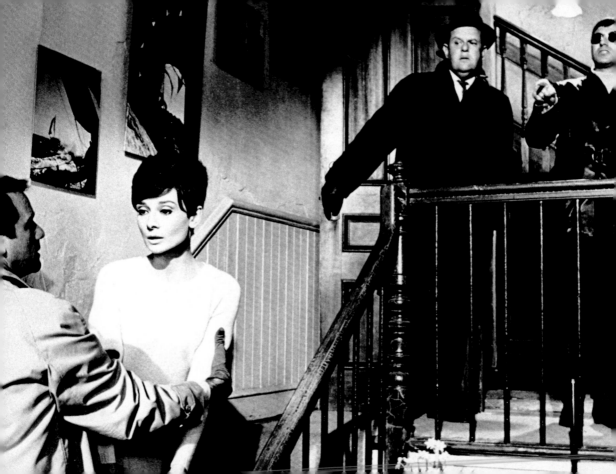

Though Audrey got an Oscar nomination for her performance in *Wait until Dark*, the award that year went to that other Hepburn—Katharine—for *Guess Who's Coming to Dinner?*

Most of Audrey's role as a hotel receptionist in the 1951 Coronet film *One Wild Oat* was cut due to the censor's objection to "objectionable" double entendres.

"Success is like reaching an important birthday
and finding out you're exactly the same."
—AUDREY HEPBURN, 1954

"The time will come when I can afford the luxury of a husband. Just now, I haven't got the time."
—AUDREY, 1952, AFTER SHE AND FIANCÉ JAMES HANSON BROKE OFF THEIR ENGAGEMENT

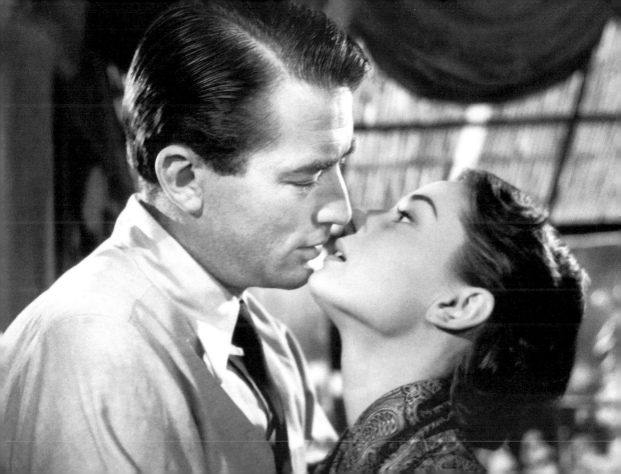

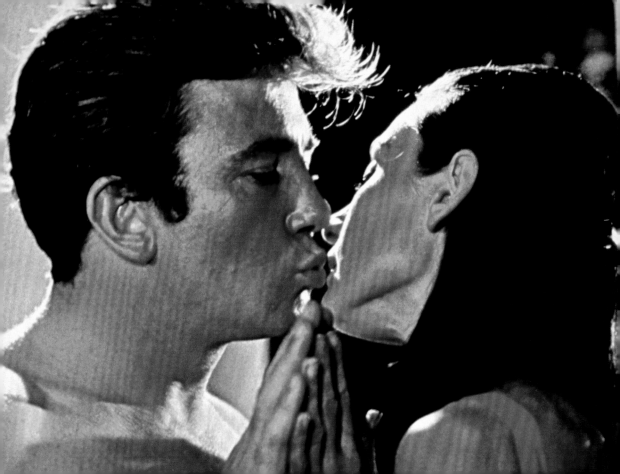

"Every girl is looking for love, whether she admits it or not, and when she finds it, her joy is greater than she can express."
—AUDREY HEPBURN, IN A 1963 MAGAZINE INTERVIEW

In the slapstick British farce *Young Wives' Tales* (1951), Audrey played the kooky Eve Lester, a young single boarder who—due to World War II conditions in England—is forced to share a small house with a variety of characters including two married couples. Though it was made before *Roman Holiday*, this film was released after Audrey's first star turn.

Audrey, shown here with Ben Gazzara, played an heiress in danger
in the international potboiler Sidney Sheldon's *Bloodline* (1979).
To get Ms. Hepburn to accept the part, the director upped
the age of the twenty-something character to thirty-five.

Audrey posed with her Oscar presenter Jean Hersholt after
winning the best actress award for her role in *Roman Holiday*
(1954). Almost thirty years later, Hepburn would go on to
win the Jean Hersholt Humanitarian Award, given by the
Academy to an "individual in the motion picture industry whose
humanitarian efforts have brought credit to the industry."

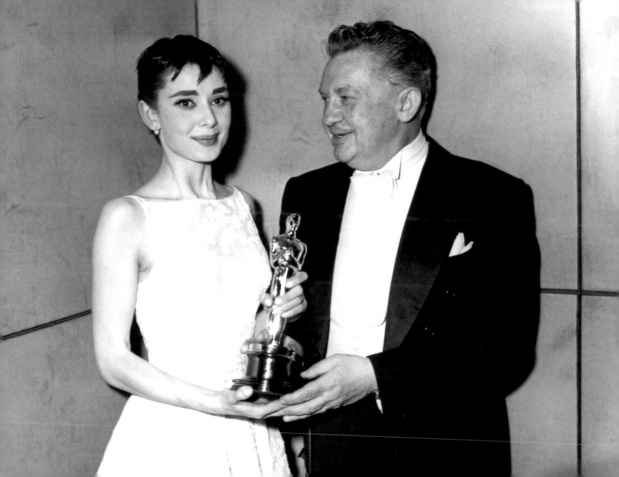

"After so many drive-in waitresses becoming movie stars, there has been this real drought, when along came class; somebody who actually went to school, can spell, maybe even plays the piano."
—BILLY WILDER

Audrey is one of nine people who has won an Oscar, a Tony, a Grammy, and an Emmy. She got an Oscar in 1953 for *Roman Holiday*, a Tony in 1954 for *Ondine*, an Emmy in 1993 for her educational miniseries *Gardens of the World with Audrey Hepburn*, and a Grammy in 1994 for *Audrey Hepburn's Enchanted Tales*, which won in the best spoken-word album for children category.

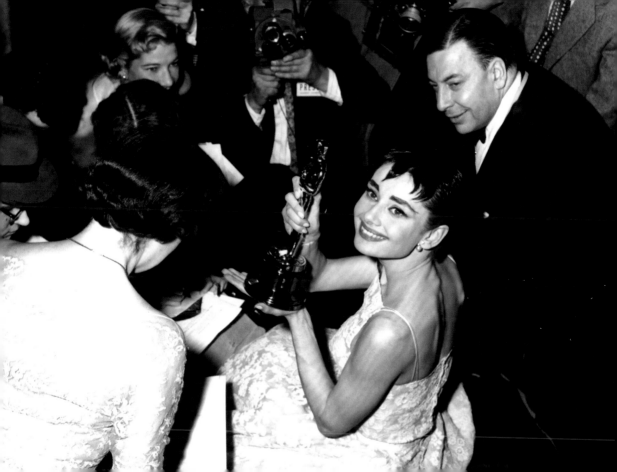

"She still had qualms about playing the role until I said
that it was not a lady of the evening that we sought
but a lopsided romantic, a dreamer of dreams."
—MARTIN JUROW, PRODUCER OF *BREAKFAST AT TIFFANY'S*,
WHO HELPED CONVINCE AUDREY TO TAKE
THE ROLE OF HOLLY GOLIGHTLY

Because French director Raymond Rouleau (shown here with Audrey and Cathleen Nesbitt) wasn't fluent in English and the rest of the cast was bilingual, playwright Anita Loos translated the script for the play *Gigi* into French for rehearsals before it was adapted back into English; this required the cast to learn two separate versions along with different phrasing and intonation.

"I depend on Givenchy in the same way that American women depend on their psychiatrists."
—AUDREY HEPBURN

George Cukor directed Audrey in the musical *My Fair Lady*;
despite its London setting, the entire film was shot on the Warner
Brother Studio lots of Burbank, California. The director agreed to
schedule the scenes in their actual order so that
Audrey could grow into the role.

"It's a shock to see Audrey Hepburn playing a role that even Raquel Welch would have had the good sense to turn down."
—*DAILY VARIETY*, ABOUT HER PERFORMANCE IN
SIDNEY SHELDON'S *BLOODLINE*

While, of course, Hubert de Givenchy did not design the costumes for *The Nun's Story* (this duty was relegated to the Warner Brothers costume department), Audrey had all the costume sketches shipped to him in Paris, and he later oversaw her fittings.

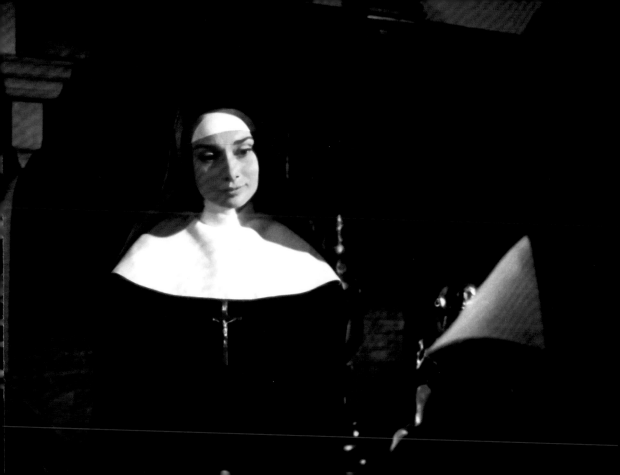

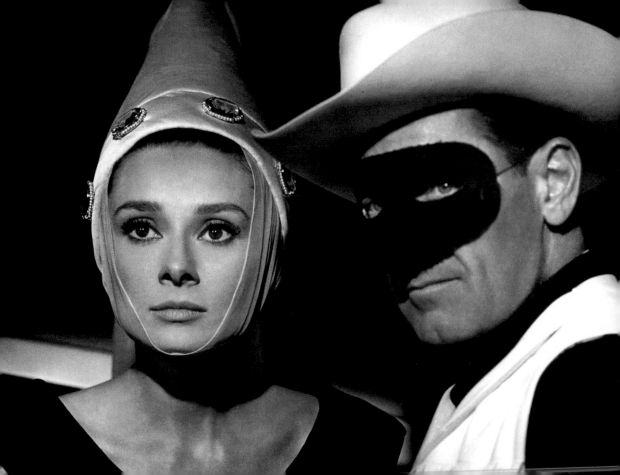

"I never think of myself as an icon. What is in other people's minds is not in my mind. I just do my thing."
—AUDREY HEPBURN

The daughter of a British banker and a Dutch baroness, Audrey Kathleen Ruston was born on May 4, 1929, in Ixelle, Belgium. Her original birth certificate was handwritten, leading certain parties to surmise incorrectly that the *u* in Audrey was actually an *n*, and that her name was originally Andrey, the feminine form of Andrew.

"I realized I had to face Audrey and I had to deal with my drinking—and I didn't think I could handle either situation."
—WILLIAM HOLDEN, ABOUT ARRIVING ON LOCATION
TO FILM PARIS WHEN IT SIZZLES

William Wyler, the director of *Roman Holiday*, started out directing low-budget Westerns. This romantic Hepburn-Peck vehicle, his first comedy in twenty years, won him an Oscar for Best Director.

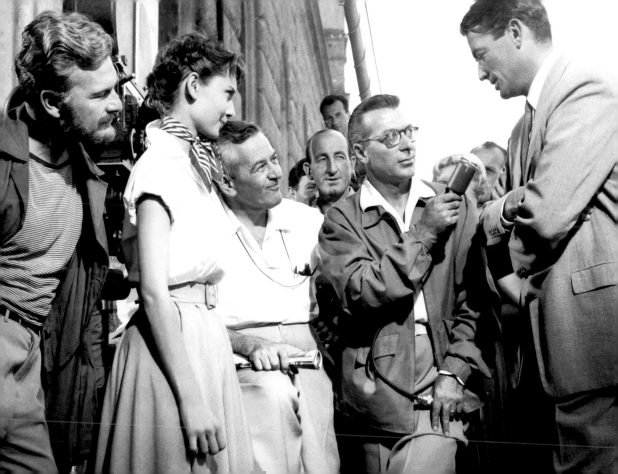

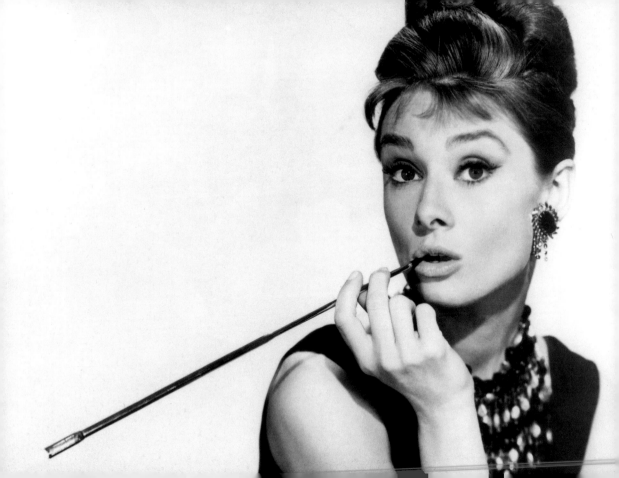

"Son image était unique. C'est une chose qu'aucune autre des grandes actrices a été incapable de créer elle-même."
("Her image was unique. It's something that no other great actress was able to create for herself.")
—HUBERT DE GIVENCHY

Audrey's television debut, *Mayerling* (1957) was based on the true story of Crown Prince Rudolf of Austria and his mistress Marie Vetsera, who were found dead at their lovers' hideaway.

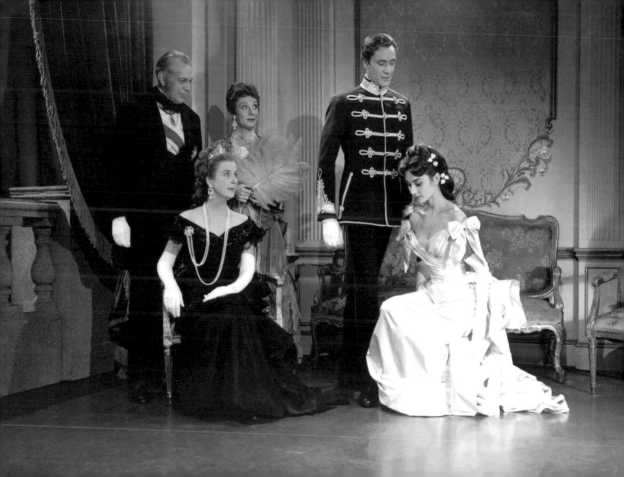

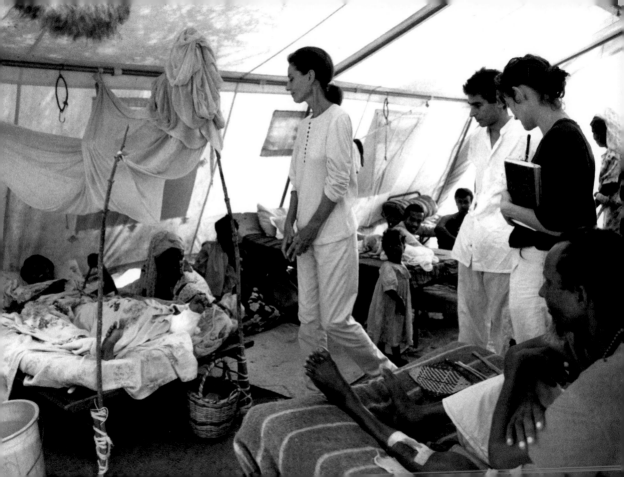

"Anyone who doesn't believe in miracles isn't a realist. UNICEF performs realistic miracles every day."
—AUDREY HEPBURN

Audrey was very eager to play Sister Luke in *The Nun's Story* because she was fervent to make the transition from her typical ingenue roles to something that would prove her ability to be a serious dramatic actress.

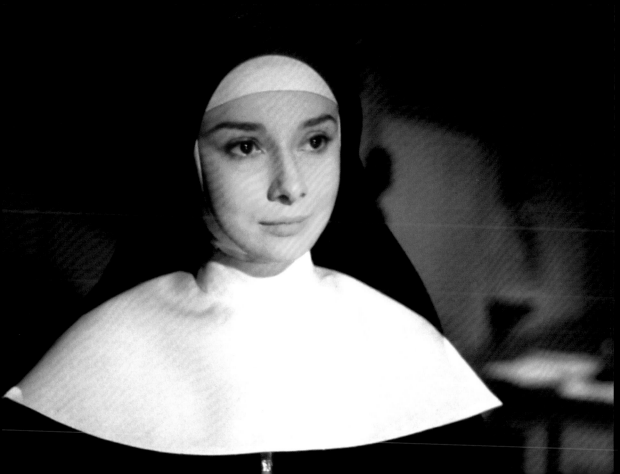

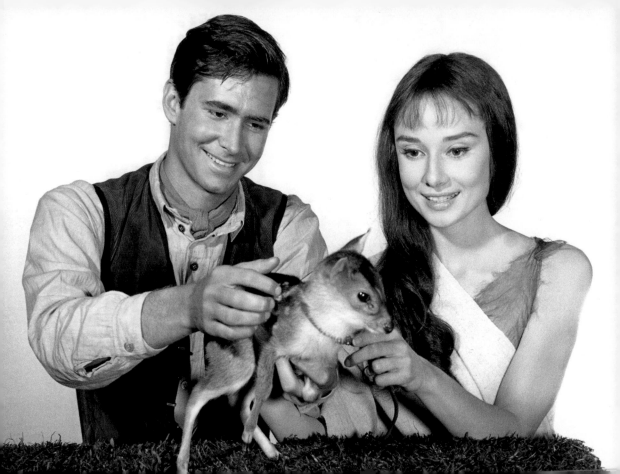

While filming *Green Mansions*, Audrey adopted her costar, Ip the fawn, in order to properly bond with the animal.

"When she burst on the world in *Roman Holiday* in 1953, she seemed a total original. Her beauty was more gamine than classic, with large expressive eyes, sculpted cheekbones, lips quick to smile, the graceful neck of a swan."

—WRITER WARREN G. HARRIS

"I had plenty of qualms about working with Audrey when we met for the first rehearsal, but from then on, working with her was one big kick."
—SHIRLEY MACLAINE, ON HER COSTAR
IN *THE CHILDREN'S HOUR*

"She was an inspiration. She brought enormous world attention to children. She raised the profile of the challenges they face."
—UNICEF EXECUTIVE DIRECTOR CAROL BELLAMY

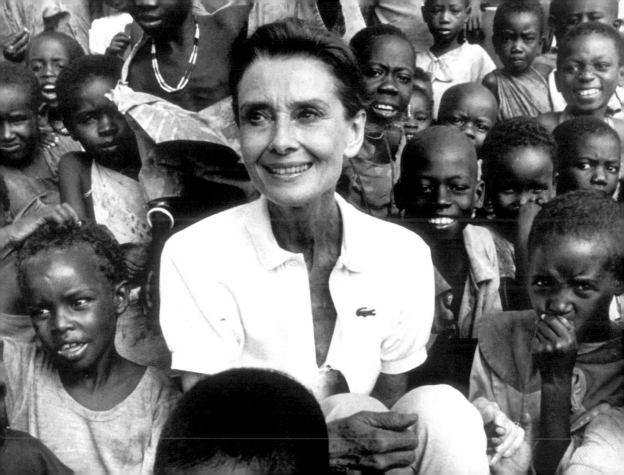

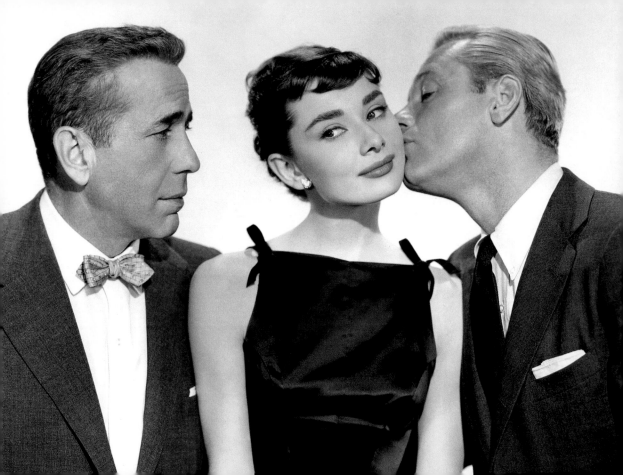

The black party dress altered by Givenchy to hide Hepburn's "hollows" behind her collarbone had what is still known as a Sabrina collar, though the designer had dubbed it "décolleté Sabrina."

"Audrey Hepburn just happened to be the most beautiful woman in movies. A head-turner. The whole point of Jane [Eyre] was that no one noticed her when she came into a room or left it."
—James Mason, on why a film adaptation of *Jane Eyre* starring Audrey never came to pass

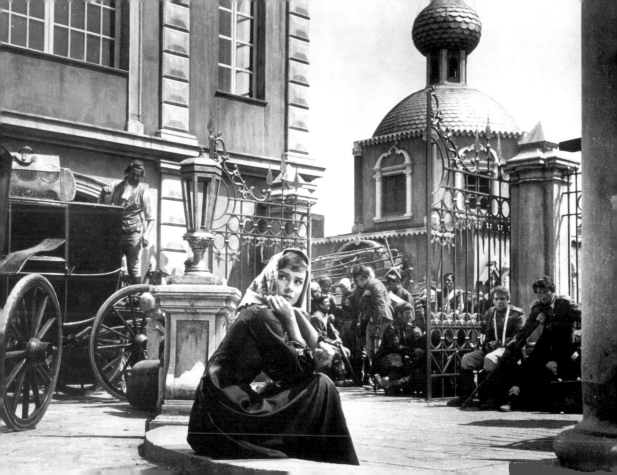

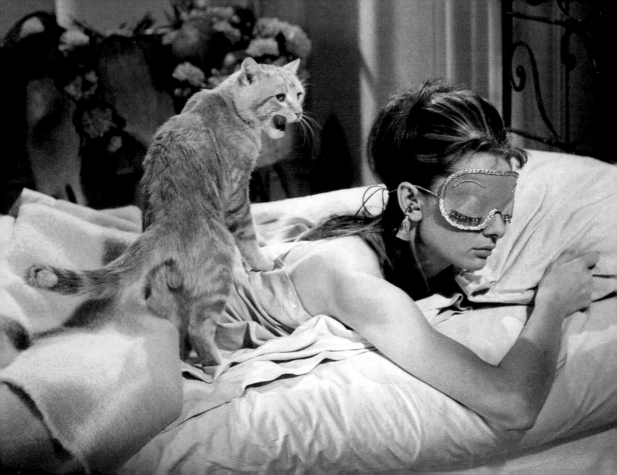

While Audrey called him "Cat" in *Breakfast at Tiffany's*, everybody on the set knew him as Rhubarb. After the film debuted, the demand for orange tabbies surged.

Hepburn and Avedon on the set of *Funny Face*. When Audrey arrived in New York on the *Queen Mary* to star in the play *Gigi*, she went straight from Pier 90 to a photo shoot by Avedon. "The first thing I saw when I came to America was the Statue of Liberty. The second, Dick Avedon, " she once quipped.

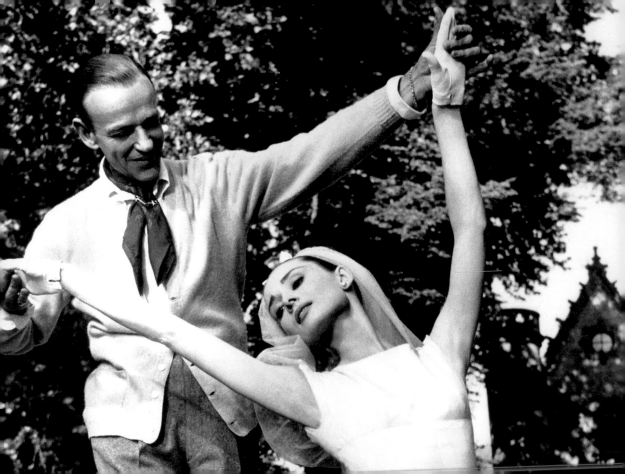

"Here I've been waiting twenty years to dance with Fred Astaire, and what do I get? Mud in my eye!"
—AUDREY ON THE SET OF *FUNNY FACE*, WHERE NINE PAIRS OF WHITE SHOES STOOD BY FOR THE MUDDY FILMING OF HER FINAL SCENE

"Audrey had an angelic quality about her. She didn't act like she was better than everyone, she just had a presence, an energy, a sort of light coming from within her that was overwhelming."
—KEVYN AUCOIN

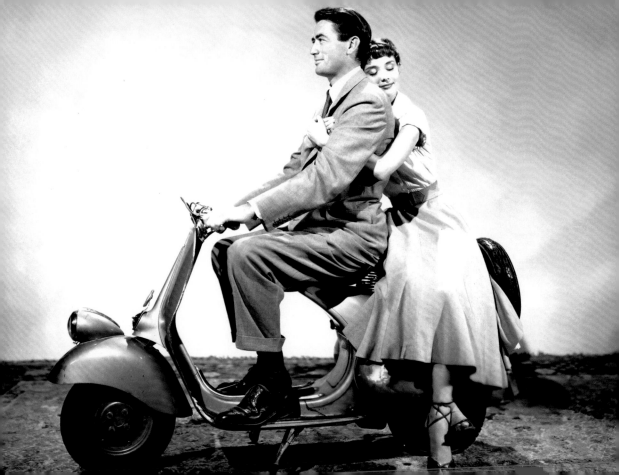

"Audrey definitely had a good heart, there was nothing mean or petty—it's a character thing. She had a good character, so I think people picked up on that too. She didn't have any of the backstabbing, grasping, petty, gossipy personalities that you see in this business. I liked her a lot; in fact, I loved Audrey. It was easy to love her."
—GREGORY PECK

Audrey's first role was uncredited. She appeared as a KLM flight attendant in the 1948 Dutch film *Nederlands in 7 Lessen* (*Dutch in Seven Lessons*).

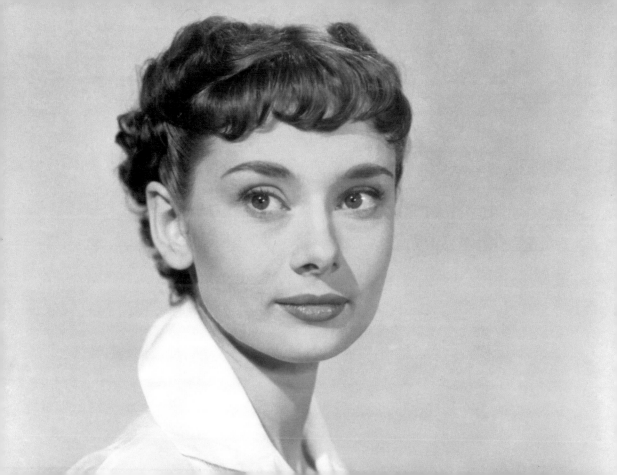

The host of the series *Gardens of the World*, Audrey Hepburn
had a tulip named after her in 1990 as well as
a hybrid tea rose in 1991.

Audrey was extremely self-conscious about performing the love scenes called for in the script for *Two for the Road* because they required her to expose more of her body than she was used to.

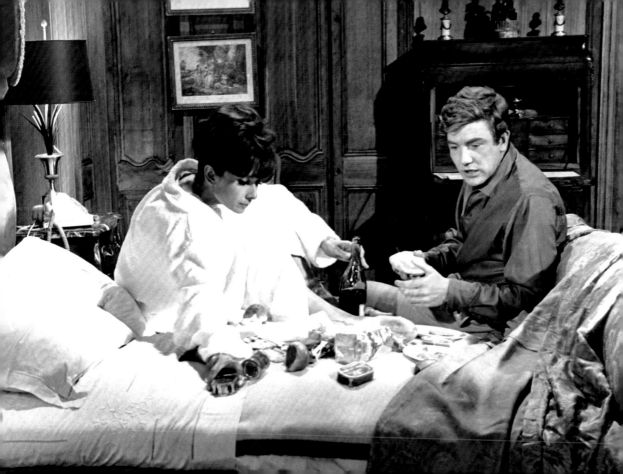

Audrey trained as a dental assistant before becoming famous.

In addition to being memorialized on a US Postal Service stamp in 2003 as part of the Legends of Hollywood series, Audrey was featured on a German stamp. However, the stamp was never put into circulation, so it is extremely rare. This cancelled one went for €53,000 ($66,500) at auction.

€0,56+0,26 Deutschland

Für die

Wohlfahrtspflege

Audrey Hepburn

110

+50

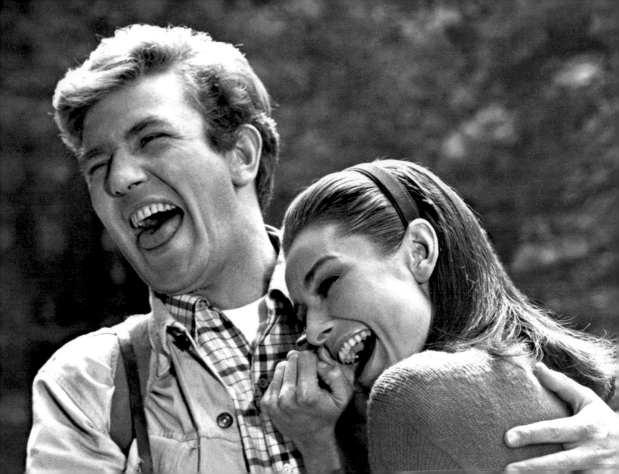

"The Audrey I saw during the making of this film I didn't even know. She overwhelmed me. She was so free, so happy. I never saw her like that. So young! . . . I guess it was Albie."
—STANLEY DONEN, DIRECTOR OF *TWO FOR THE ROAD*

After playing the heroine's younger sister, Nora, in the overwrought crime drama *Secret People* (1952), Audrey hit it big with *Roman Holiday* the following year.

"If you just keep your mind off the poetry and on the pyjamas, everything'll be all right; see?"
—JOE BRADLEY TO PRINCESS ANN IN *ROMAN HOLIDAY*

"She slips across the stage without touching the floor, and when she is in repose, she's lovelier still."
—*NEW YORK HERALD TRIBUNE* REVIEW OF HEPBURN'S
PERFORMANCE IN THE BROADWAY PLAY *ONDINE* (1954)

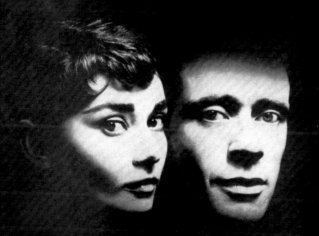

ONDINE

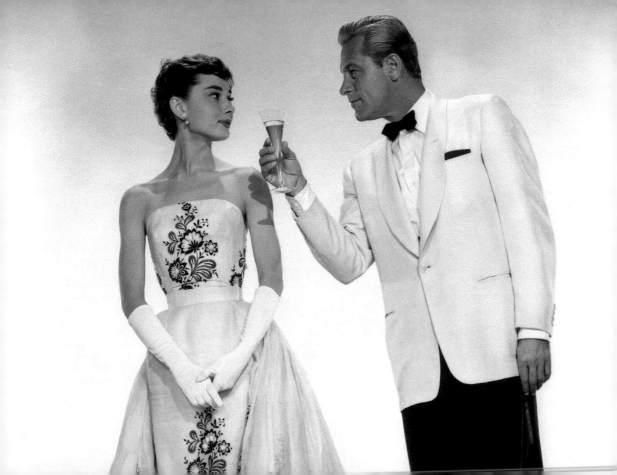

For the film *Sabrina*, designer Hubert de Givenchy at first believed that he would be providing wardrobe for Katharine Hepburn, because he hadn't ever heard of an Audrey. He would later become the costumer of choice for the rest of her career.

Humphrey Bogart wasn't exactly thrilled about Audrey playing the title role in *Sabrina*. He was hoping his wife, Lauren Bacall, could fill the shoes of Sabrina.

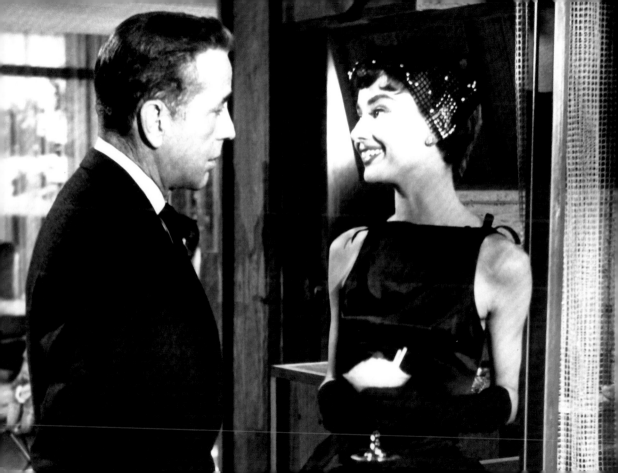

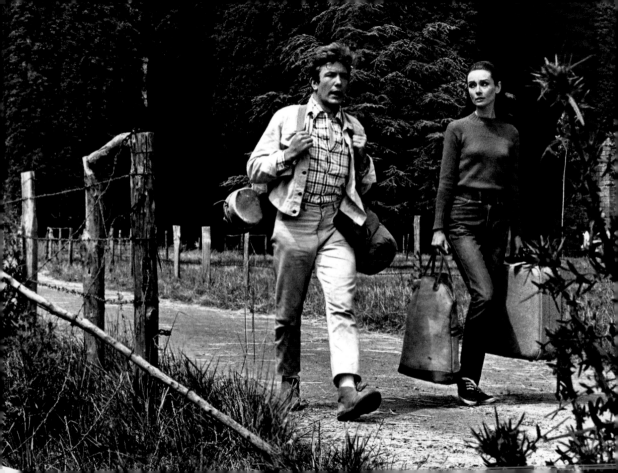

Albert Finney was one of the few leading men who were younger than Audrey. Though she didn't look it, Hepburn was seven years older than her *Two for the Road* costar.

Mod model Suzy Parker supposedly inspired Audrey's
Jo Stockton character in *Funny Face*.

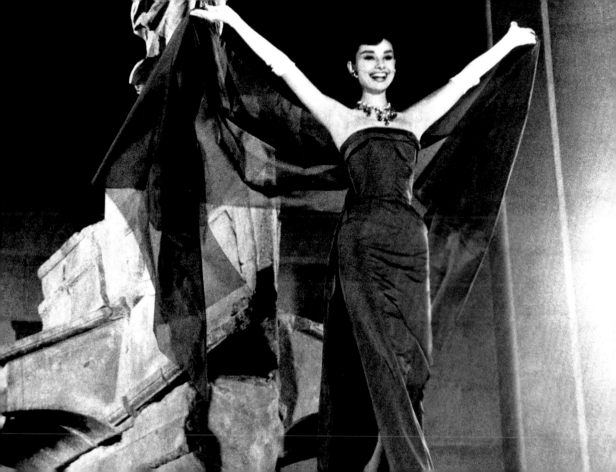

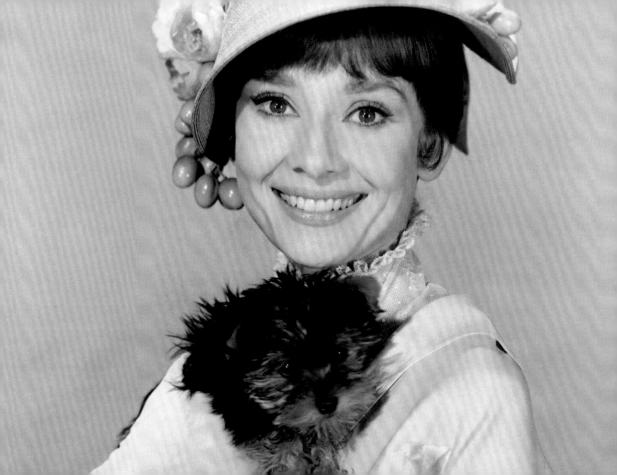

Audrey Hepburn's terrier appears as the dog in the basket during the "Anna Karenina" train shot in *Funny Face*.

The ridiculous rumor that Hepburn demanded a bidet while filming *The Nun's Story* in the Congo was roundly refuted by the actress.

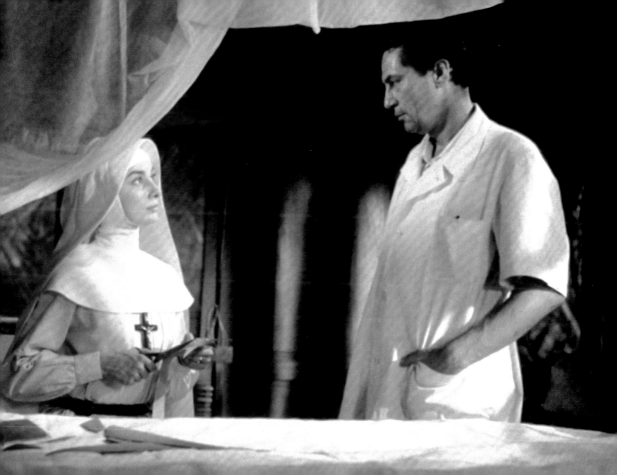

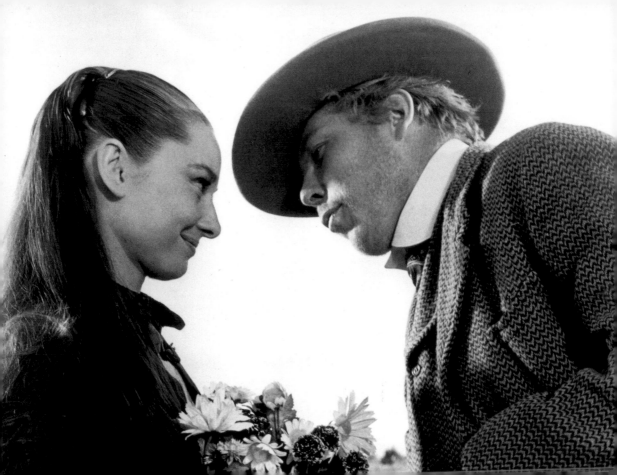

In *The Unforgiven*, Hepburn played the unlikely role of a pioneer woman who had been brought up as a white settler, but was actually descended from the Kiowa tribe. After Audrey's terrible accident, John Huston expressed incredible guilt about ever having made the movie.

"I'm a wacky, dizzy girl who takes nothing seriously."
—AUDREY, DESCRIBING HER
HOLLY GOLIGHTLY CHARACTER

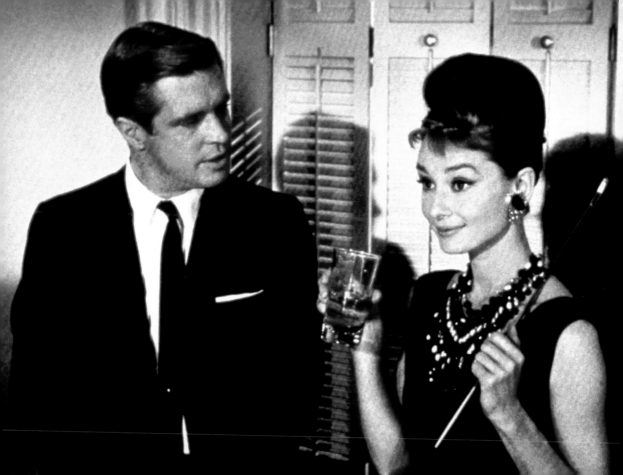

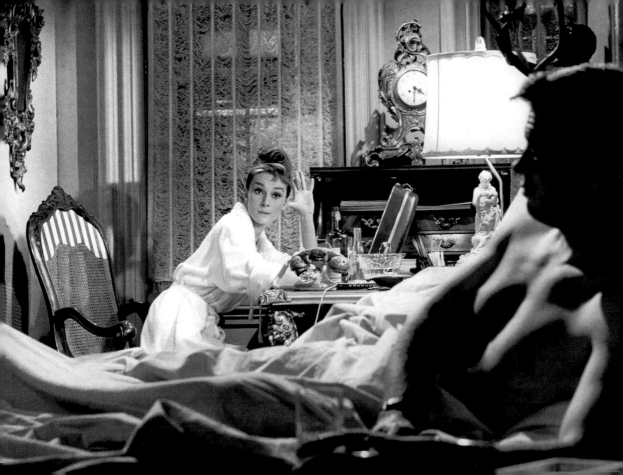

Breakfast at Tiffany's leading man, George Peppard, was considered an up-and-coming golden boy with great potential. However, his leading lady didn't find it easy working with the Lee Strasbourg-coached Method actor, and costar Patricia Neal (who had worked with him at the Actors Studio) thought that he'd gotten "big-headed."

"She never considered herself a good gardener. She liked
to talk about how good she was at pulling weeds.
But that's because she was so modest."
—JANIS BLACKSCHLEGER, EXECUTIVE PRODUCER OF THE
PBS PROGRAM *GARDENS OF THE WORLDS*
WITH AUDREY HEPBURN

"The part was probably one of the most rigorous roles Audrey ever played."
—TERENCE YOUNG, DIRECTOR OF *WAIT UNTIL DARK*

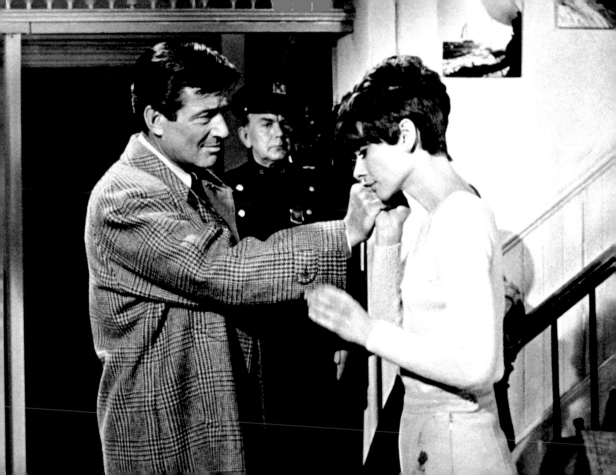

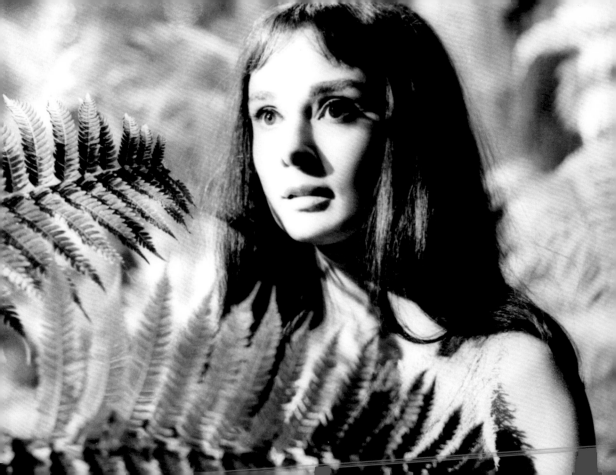

"There are certain shades of limelight that can wreck a girl's complexion."
—AUDREY HEPBURN

"Playing a love scene with a woman as sexy as Audrey, you sometimes get to the edge where make-believe and reality are blurred. The time spent with Audrey is one of the closest I ever had."
—ALBERT FINNEY

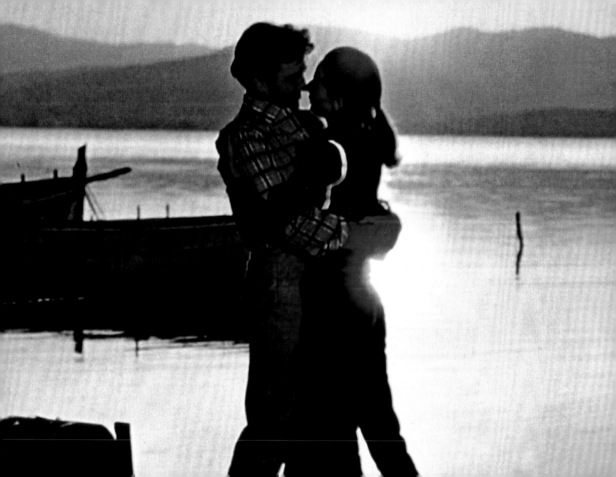

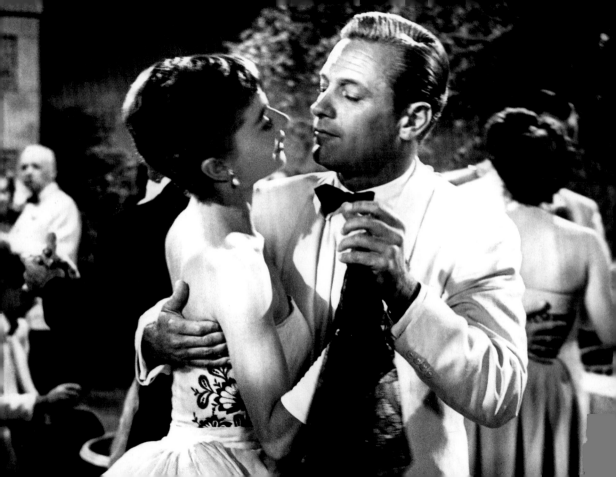

"People associate me with a time when movies were pleasant, when women wore pretty dresses in films and you heard beautiful music."
—AUDREY HEPBURN

"Sabrina was a dreamer who lived a fairy-tale, and she was a romantic, an incorrigible romantic, which I am. I could never be cynical. I wouldn't dare. I'd roll over and die before that."
—Audrey Hepburn

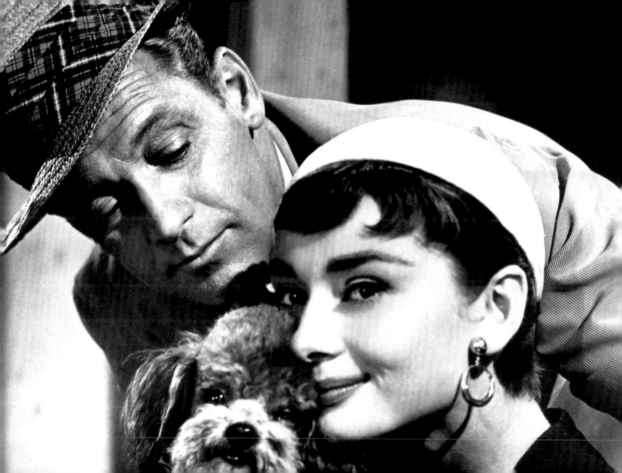

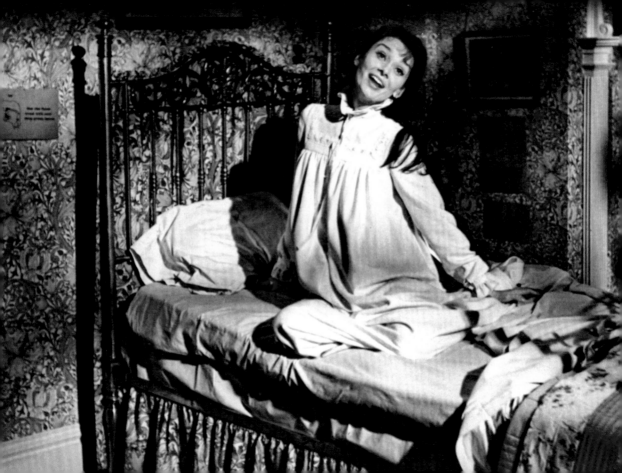

"She did the best that we could be; she was perfectly charming and perfectly loving. She was a dream. And she was the kind of dream that you remember when you wake up smiling."
—RICHARD DREYFUSS

"There is more to sex appeal than just measurements. I don't need a bedroom to prove my womanliness. I can convey just as much sex appeal, picking apples off a tree or standing in the rain."
—AUDREY HEPBURN

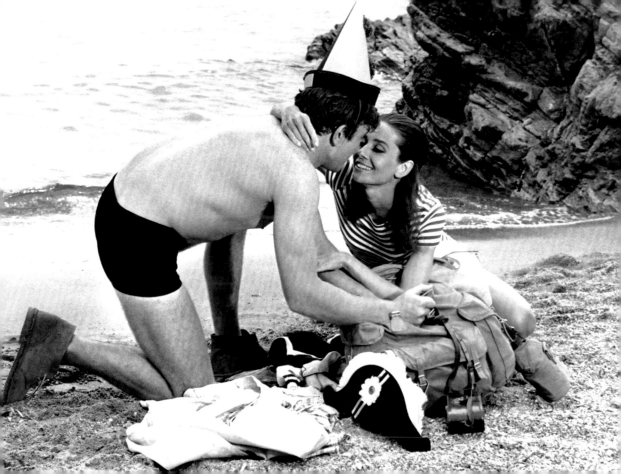

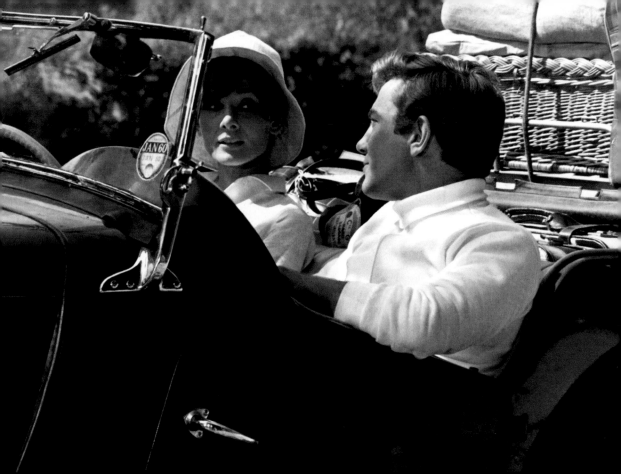

During several of the car sequences in *Two for the Road*, Audrey and Albert were required to direct themselves. They pushed the camera's buttons and Stanley Donen, director, followed in another car.

"What is needed in order to really become a star is an extra element which God gives you or doesn't give you God kissed Audrey Hepburn on the cheek and there she was."
—BILLY WILDER

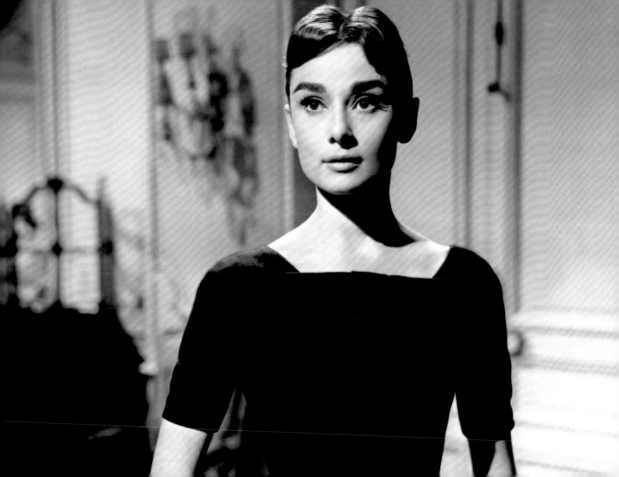

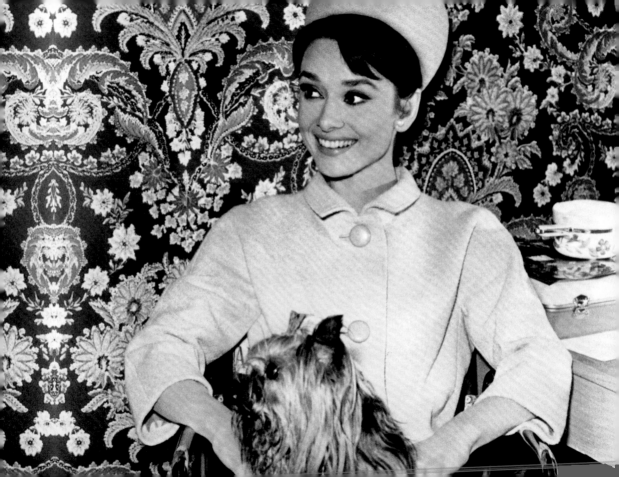

During the filming of *Love in the Afternoon*, Mel bestowed upon Audrey one of the best gifts she had ever received: A Yorkshire terrier whom she named Famous.

"[Audrey is] alternately regal and childlike, with the qualities of someone who came from a better and purer world."
—BOSLEY CROWTHER

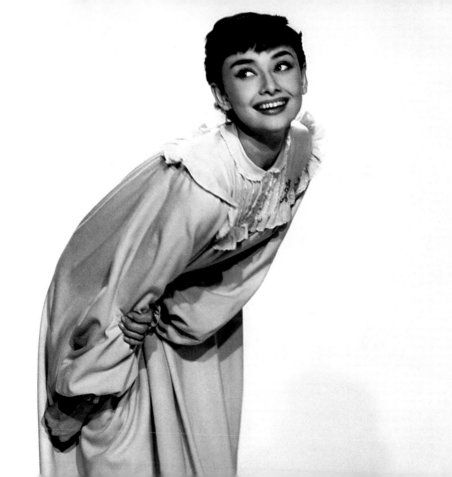

"I have a great sense of privacy. Writers have to have an angle. If you say less than what you might tell your husband or your doctor, then you're 'mysterious' Basically, I don't like the one-sided talk about myself. I don't enjoy the process of cross-examination; I find it absolutely sapping. [I've] been made mistrustful by being burned."
—AUDREY HEPBURN

Audrey never enjoyed driving and did not get her licence until the 1950s. Mel bought her a brand-new Thunderbird, but shortly after, a woman rear-ended her and, blaming Audrey, filed a lawsuit against her celebrity victim. After this, Audrey sold her car and swore she'd never drive again.

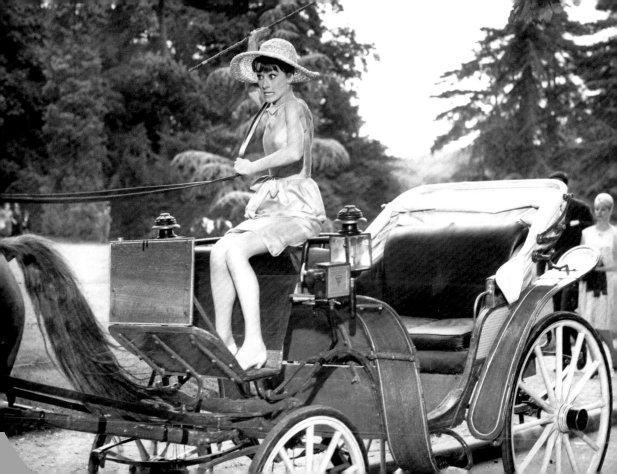

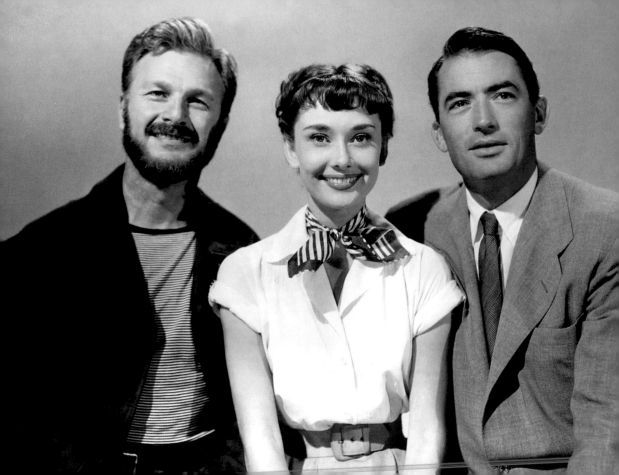

"Thanks to their first glimpse of Audrey Hepburn in *Roman Holiday*, half a generation of young females stopped stuffing their bras and teetering on stiletto heels."
—*THE NEW YORK TIMES*, JANUARY 23, 1993

There were so many paradoxes in that face. Darkness and purity; depth and youth; stillness and animation. I had photographed many of the greats, Garbo included, but I felt I'd made a real discovery when I found Audrey."

—ANTHONY BEAUCHAMP

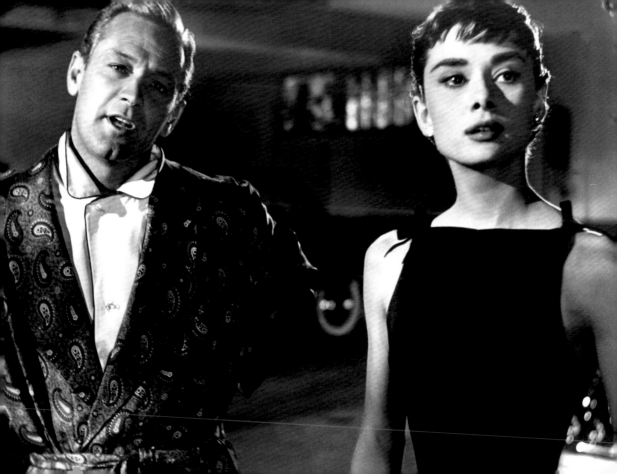

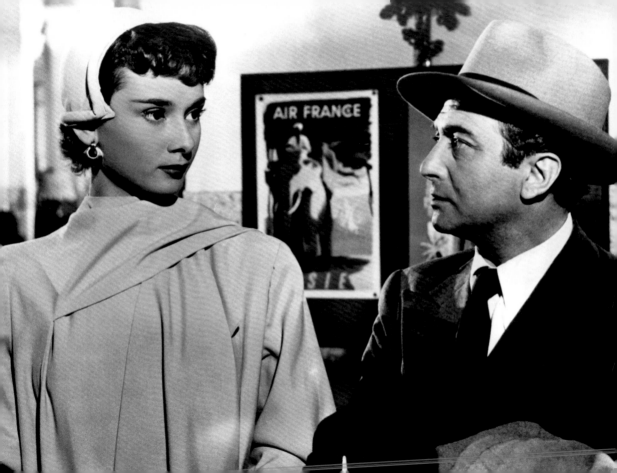

Audrey's first leading role was in *Monte Carlo Baby*. In it, she played the role of Linda Farrel. For the French version of the movie, *Nous irons à Monte Carlo*, her character's name got changed—for reasons unknown—to Melissa Walter.

"Holly is so contrary to me. She frightens me. This part called for a extroverted character. I am very much an introvert."
—AUDREY ON HER ROLE IN *BREAKFAST AT TIFFANY'S*

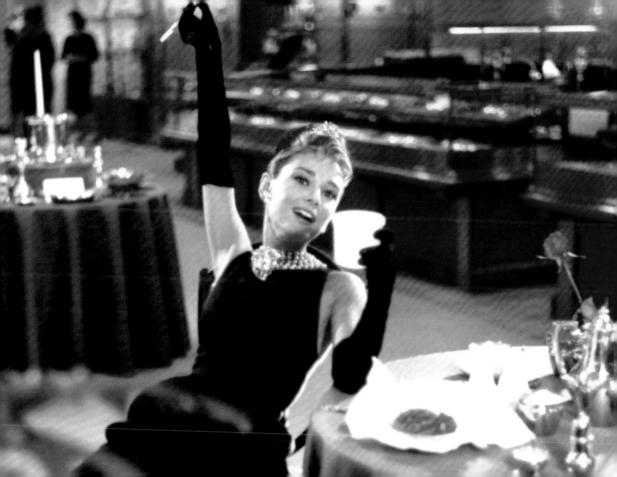

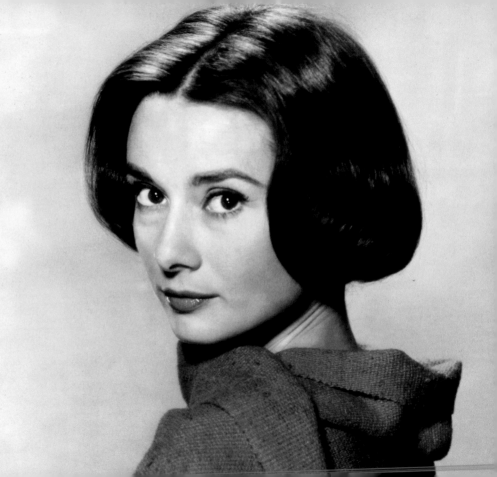

"Now all I have to do is learn how to act."
—AUDREY HEPBURN UPON LANDING
THE PART OF GIGI

After filming *Sabrina*, Hepburn met actor Mel Ferrer at a party hosted by Gregory Peck.

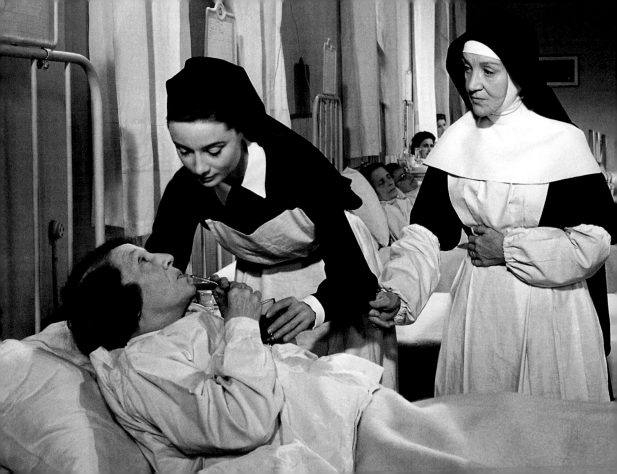

During the filming of *A Nun's Story*, Audrey fell ill with a brutal case of kidney stones.

"I didn't want to exploit her life and death to my advantage—to get another salary, to be perhaps praised in a movie."
—AUDREY ON WHY SHE DECLINED THE ROLE OF ANNE IN *THE DIARY OF ANNE FRANK*.

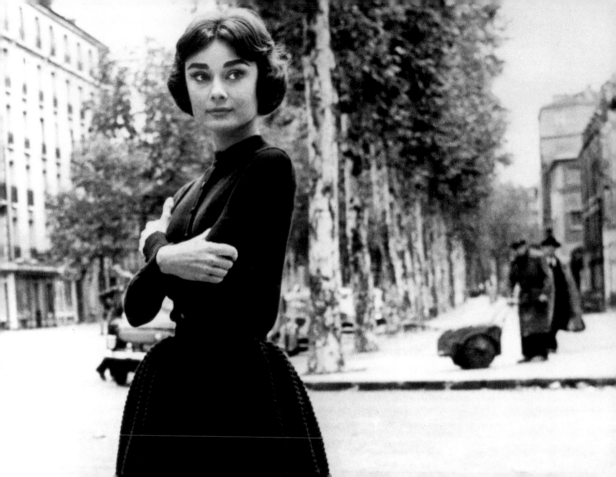

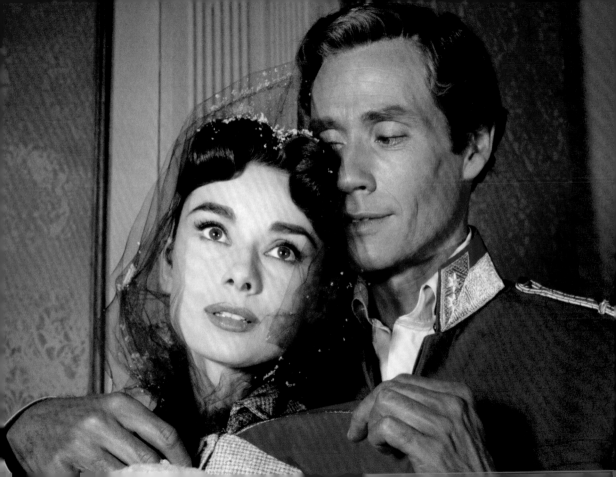

Her role as Crown Prince Rudolph's mistress, Maria Vetsera, in a
Producers' Showcase production of *Mayerling* was Audrey's
first TV outing. The title of the work referred not to
a person but to the name of the Austrian village
where the lovers met their end.

"A quality education has the power to transform societies in a single generation, provide children with the protection they need from the hazards of poverty, labor exploitation and disease, and given them the knowledge, skills, and confidence to reach their full potential."
—Audrey Hepburn

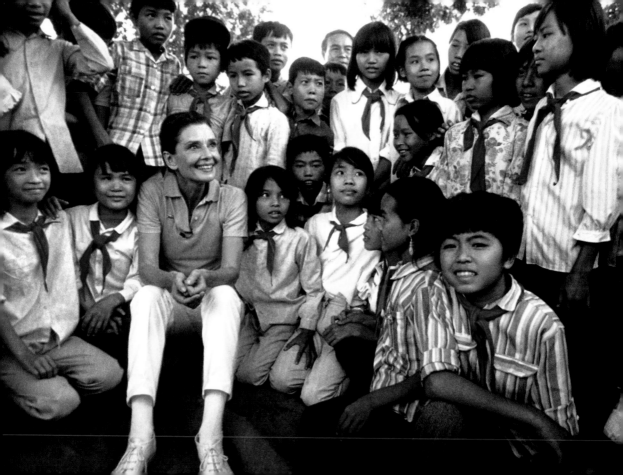

"I don't think Holly knows as many men as she pretends. It's just a jazzy façade she creates, because basically she is a small-town girl who's out of her depth."

—AUDREY HEPBURN ON HER CHARACTER
IN *BREAKFAST AT TIFFANY'S*

"You could take Audrey into Sears Roebuck or Givenchy or Ralph Lauren or an army surplus store—it didn't matter, she'd put something on and you'd say, 'It's her!'"
—RALPH LAUREN

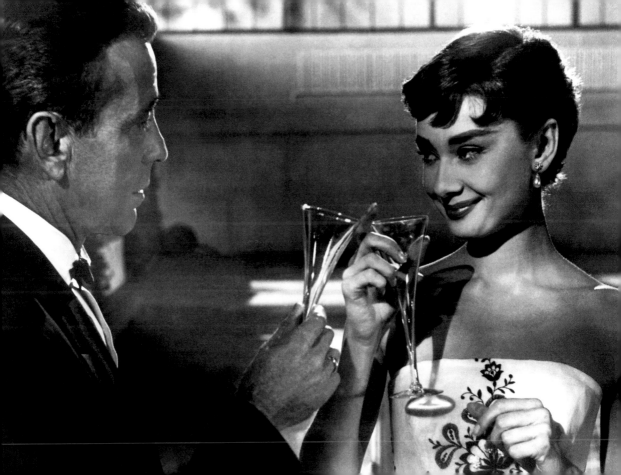

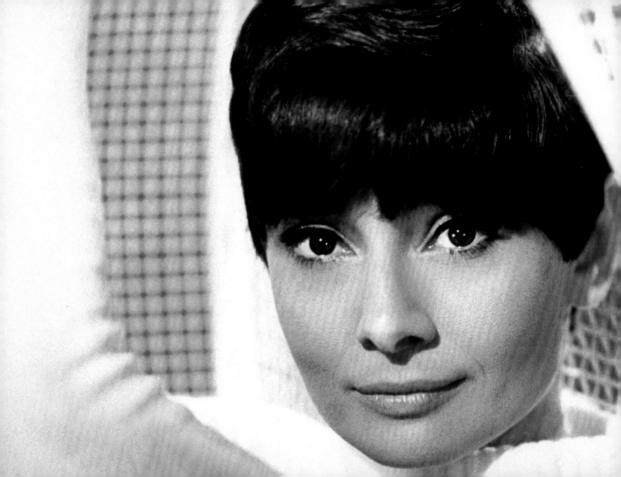

"I am proud to have been in a business that gives pleasure, creates beauty, and awakens our conscience, arousing compassion, and perhaps most importantly gives millions a respite from our so violent world."
—AUDREY HEPBURN

"Audrey was a lady with an elegance and charm that was unsurpassed, except by her love for underprivileged children all over the world. God has a most beautiful new angel now that will know just what to do in heaven."

—Elizabeth Taylor

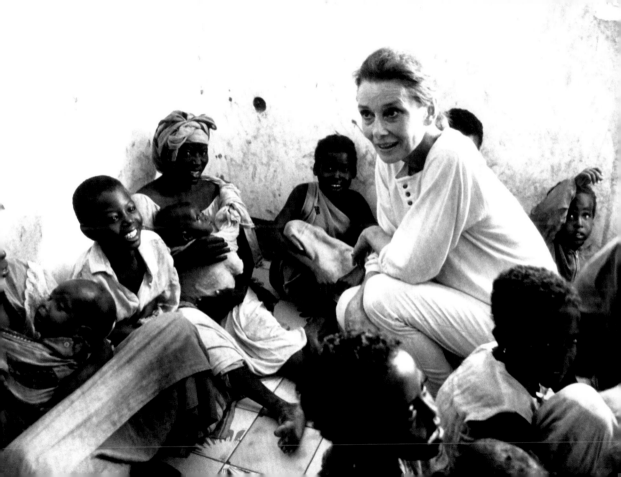

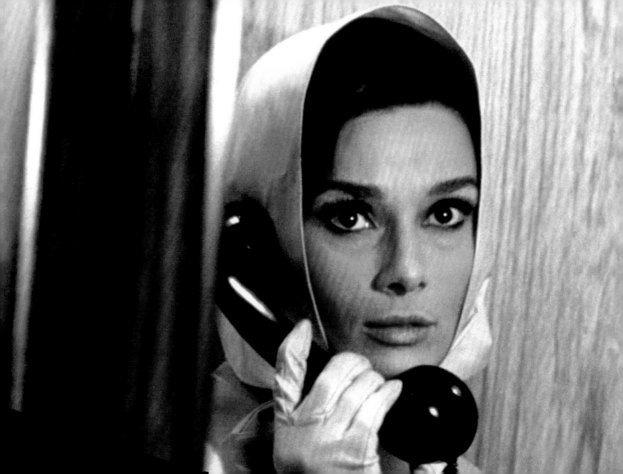

With Audrey twenty-five years his junior, Cary Grant felt uncomfortable with his character in *Charade* chasing Audrey's. Hearing the veteran actor's concerns, writer Peter Stone switched all the aggressive lines to Audrey's character, and Grant excitedly accepted the role.

"I was born with something that appealed to an audience at that particular time . . . I acted instinctively. I've had one of the greatest schools of all—a whole row of great, great directors."
—Audrey Hepburn

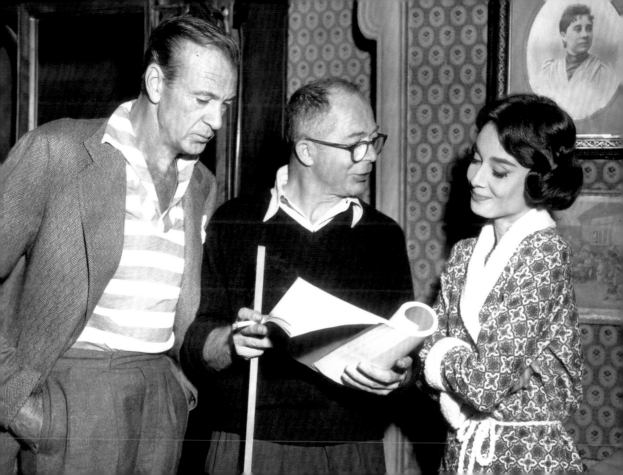

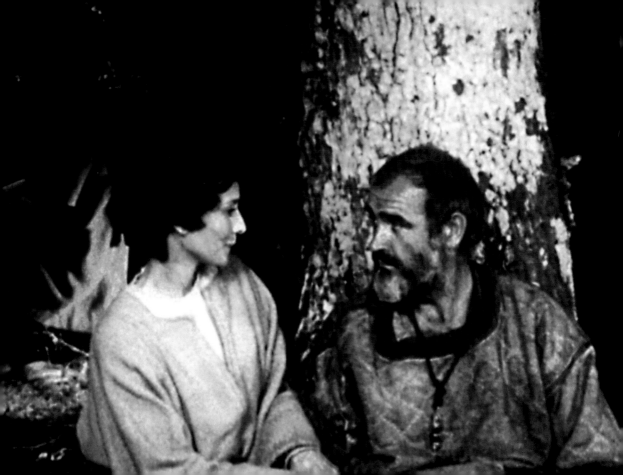

In 1976, Audrey returned from an eight-year break in the movie
Robin and Marian. She costarred as Maid Marian
to Sean Connery's Robin Hood.

"I never thought I would end up in pictures
with a face like mine."
—AUDREY HEPBURN

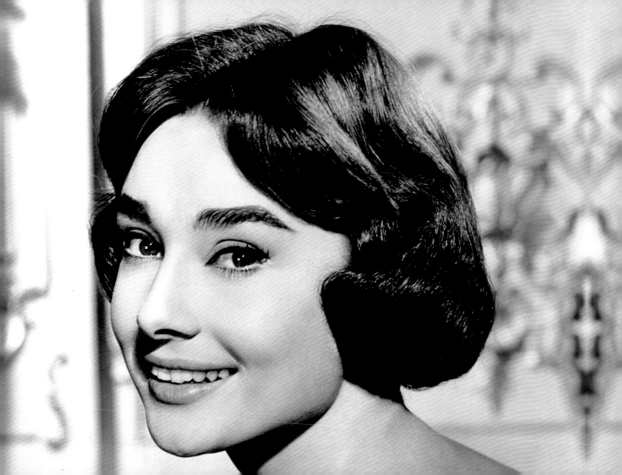

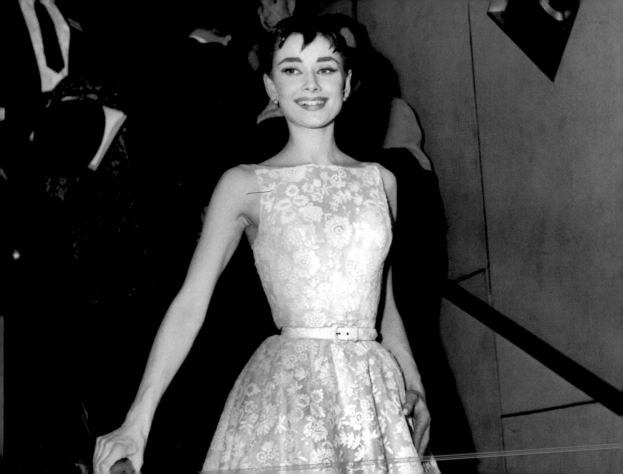

"I decided, very early on, just to accept life unconditionally;
I never expected it to do anything special for me, yet I
seemed to accomplish far more than I had ever hoped.
Most of the time it just happened to me
without my ever seeking it."
—AUDREY HEPBURN

Pregnant with her first son, Sean, Audrey took a sabbatical and remained in bed most of the time, eagerly awaiting motherhood. She considered her life incomplete without raising a family.

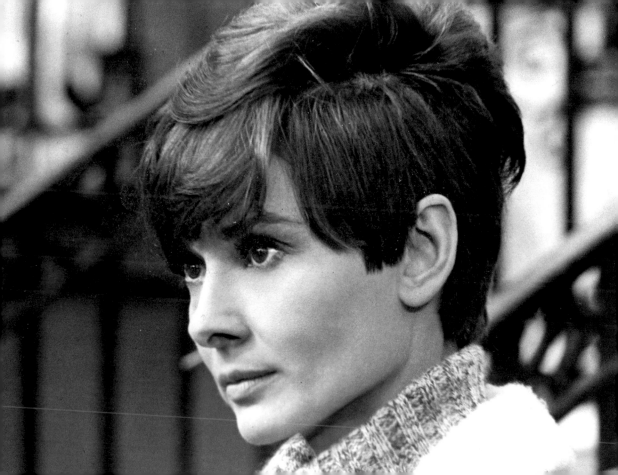

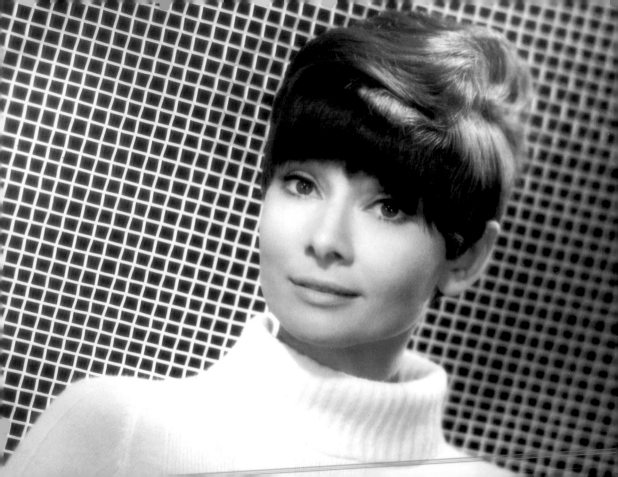

"There is not a woman alive who does not dream
of looking like Audrey Hepburn."
—HUBERT DE GIVENCHY

"Voila! I have found Gigi!"
—author Collette

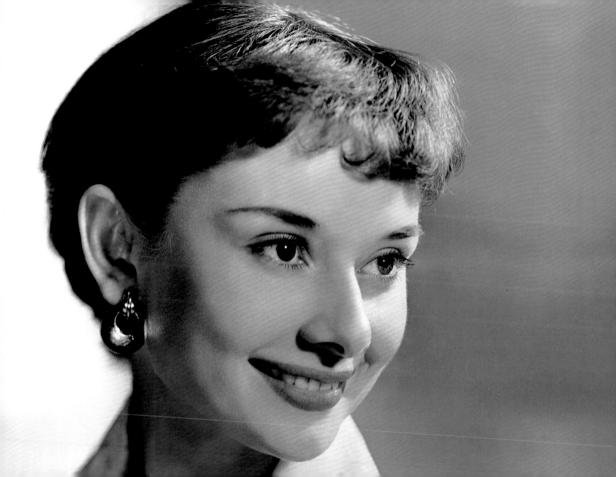

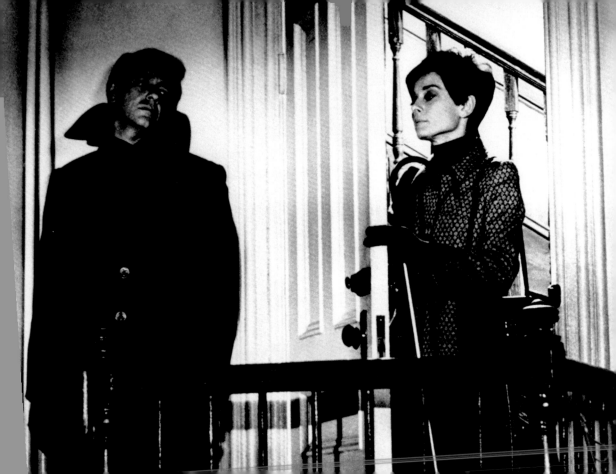

The producers found the part of villainous Harry Roat difficult to cast because no actor wanted to be seen terrorizing a blind woman, let alone beloved screen icon Audrey Hepburn. Alan Arkin finally accepted the job.

"In every movie I have ever watched, starting with *Roman Holiday*, I was in love with Audrey Hepburn. I played every part. I was Gregory Peck a long time ago! I was Bill Holden, I was Cary Grant, I was her biggest fan."
—Ralph Lauren

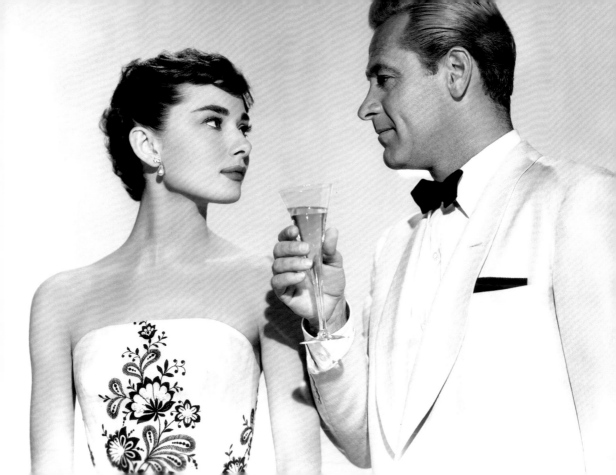

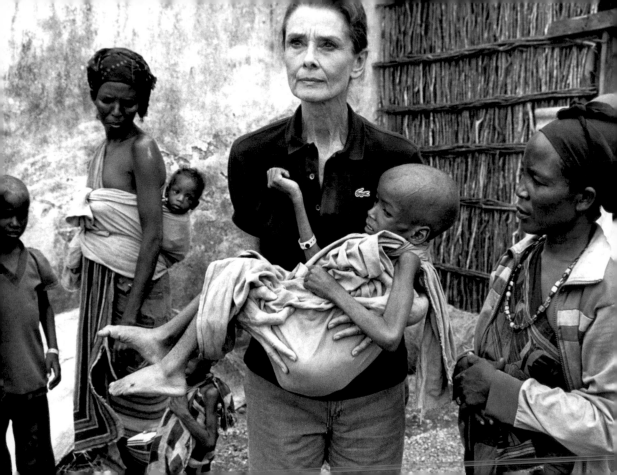

"I got to know Ms. Hepburn as the UNICEF goodwill ambassador, particularly in regard to her work on behalf of the children of Africa. I think it was her trip in September to Somalia that really did raise the public's consciousness to the tragedy that was befalling the children in Somalia. So for her dedication, her thoughtfulness, her dignity and quiet passion, she not only will be missed by all of us around the world, but particularly by the children."

—SENATOR NANCY KASSEBAUM, IN A SENATE ADDRESS, JANUARY 21, 1993 (THE DAY AFTER HEPBURN'S DEATH)

Audrey appeared on nine covers of *Life* magazine,
more than any other personality.

Audrey has a street in the town of Doorn, Switzerland, named in her honor: Audrey Hepburnlaan.

"She was so gracious and graceful that everybody fell in love with her after five minutes. Everybody was in love with this girl, I included. My problem was that I am a guy who speaks in his sleep. I toss around and talk and talk . . . But fortunately, my wife's first name is Audrey as well."
—BILLY WILDER

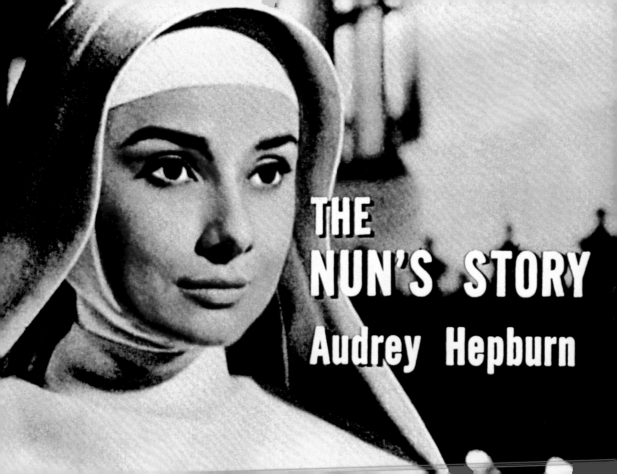

THE
NUN'S STORY
Audrey Hepburn

Eschewing sound stages, Warner Brothers filmed *The Nun's Story* on location in Belgium, Italy, and Africa.

"I called them and said . . . 'This girl is going to win the Academy Award in her first role, and her name must be up above the title with mine.'"
—GREGORY PECK, ABOUT *ROMAN HOLIDAY*

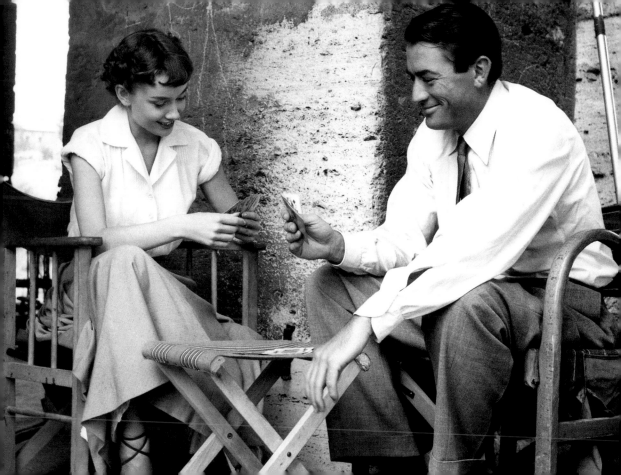

Audrey has appeared on the covers of such periodicals as *Picturegoer, Movies, Marie Claire, People, Vanity Fair,* and *Town & Country.* In 1990, *People* magazine named her as one of the 50 Most Beautiful People in the World.

"Gregory Peck . . . the beautiful, kind and gentle hero of countless movies. I thought he'd be just like that; he was."
—AUDREY HEPBURN, ABOUT HER COSTAR IN *ROMAN HOLIDAY*

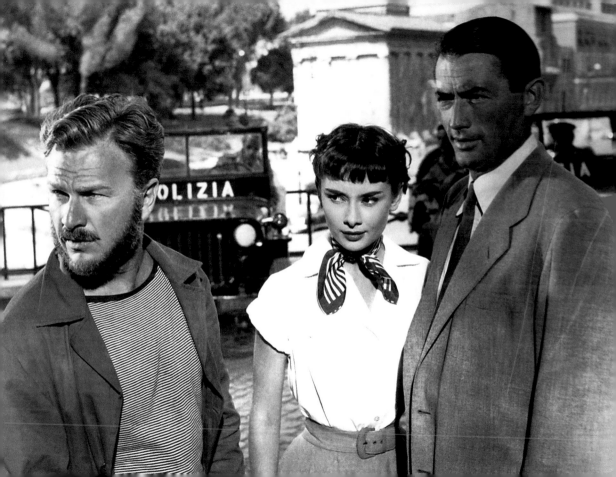

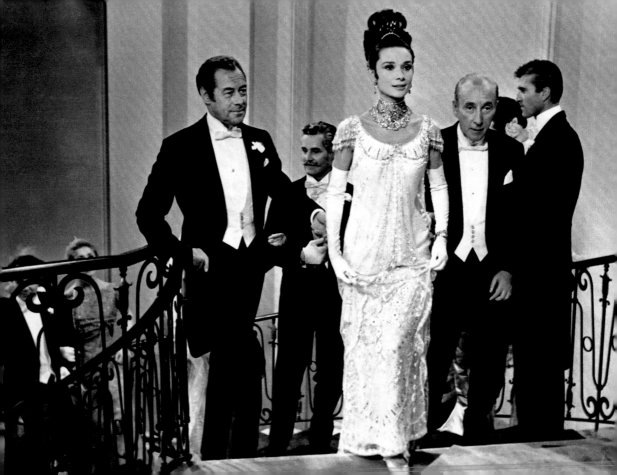

Despite the talent of newcomer Julie Andrews, who played
Eliza in the Broadway production, and hard lobbying
by Elizabeth Taylor, the much-sought-after role of
Eliza Doolittle in *My Fair Lady* went to Audrey.

"I was crazy about *Two for the Road* and thought she really let her defenses down in it. That was a real person."
—BILLY WILDER

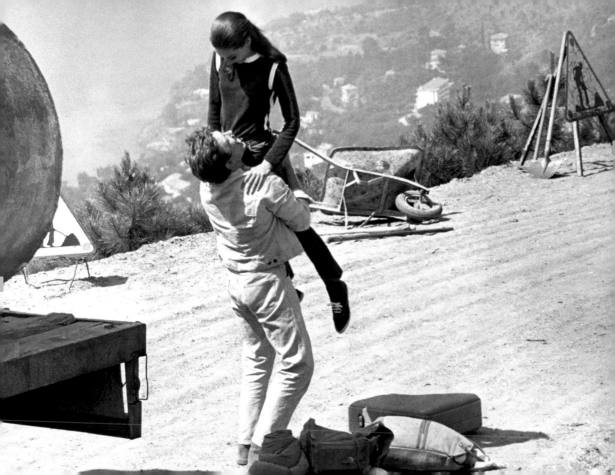

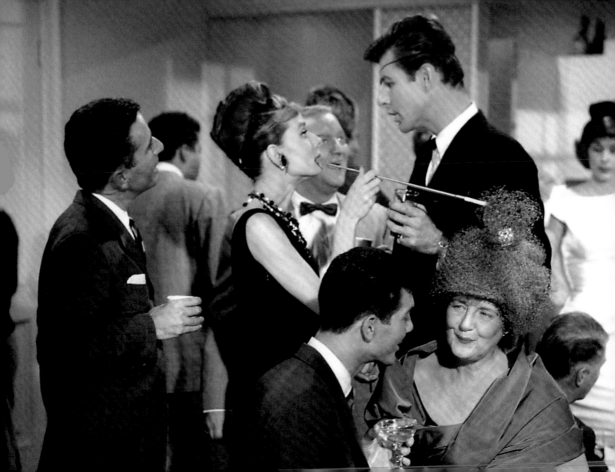

Audrey earned a whopping $750,000 for completing *Breakfast at Tiffany's*. This was an extraordinarily high salary trumped only by that of Elizabeth Taylor.

In *Robin and Marian*, the wagon Audrey is riding in inadvertently overturns into a river. Audrey handled the mishap with grace, and the director liked it so that instead of reshooting the scene, he went with the blooper and had Robin lift her to safety in the following scene.

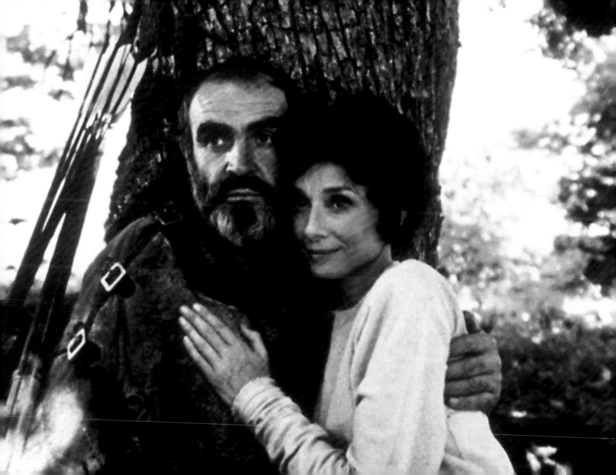

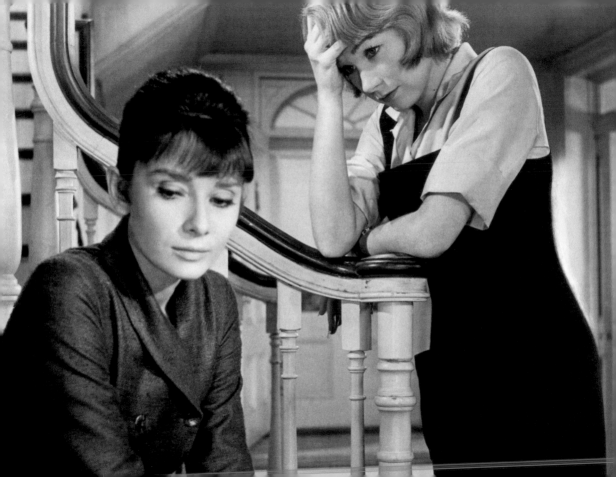

"Audrey was the kind of person who when she saw someone else suffering tried to take their pain on herself. She was a healer. She knew how to love. You didn't have to be in constant contact with her to feel you had a friend. We always picked up right where we left off."
—SHIRLEY MACLAINE

"People don't realize how educated she was. She spoke several languages fluently. She had a wonderful speaking voice—extremely cultured, with wonderful pronunciation. She was a joy to listen to. She never raised her voice, so you were drawn in, you had to listen carefully, and you wanted to."
—STANLEY DONEN

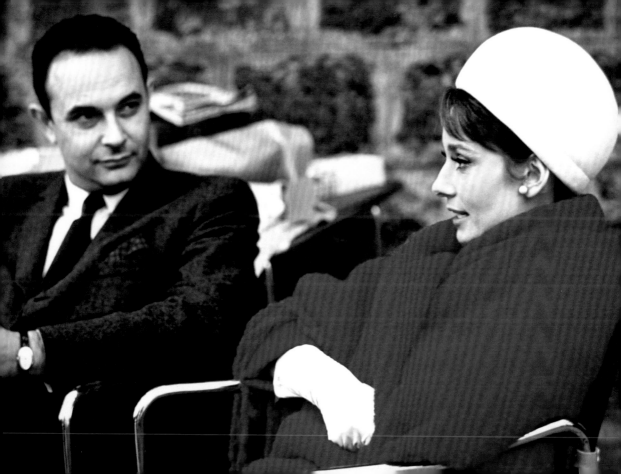

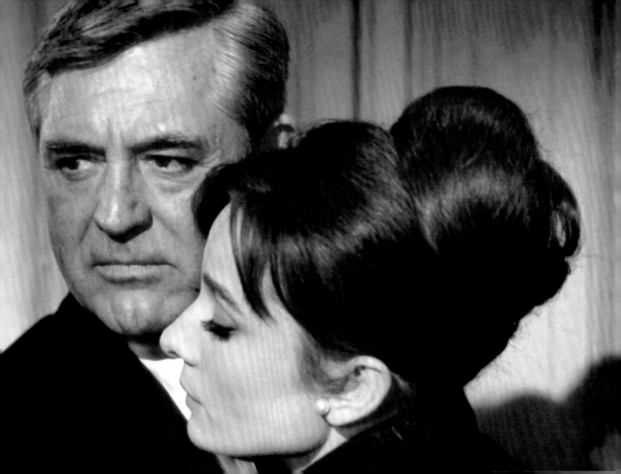

Audrey was more than happy to reunite with her *Funny Face* director Stanley Donen for *Charade*. She was also thrilled to finally be working with actor Cary Grant.

"As a child, seeing suffering around her, that awakened her to compassion. Instead of making her bitter, as it did some, it made her generous, giving. The surprising thing is that she was like that with everyone. Every gesture was gracious, every word. She wasn't ever trying to impress you. She was just like that."
—Princess Catherine Aga Khan (wife of UNICEF commissioner Prince Sadruddin Aga Khan)

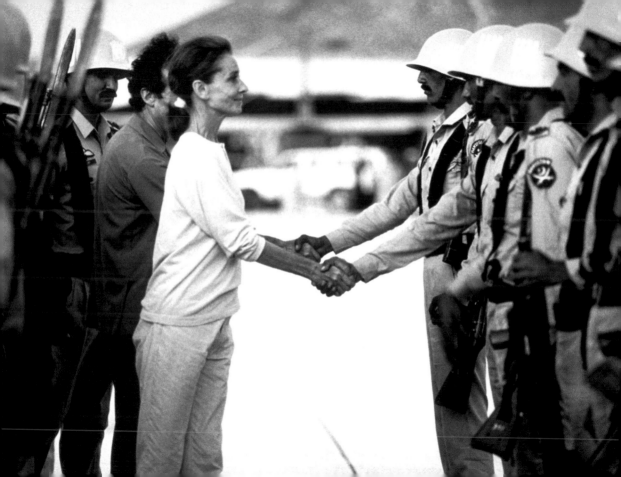

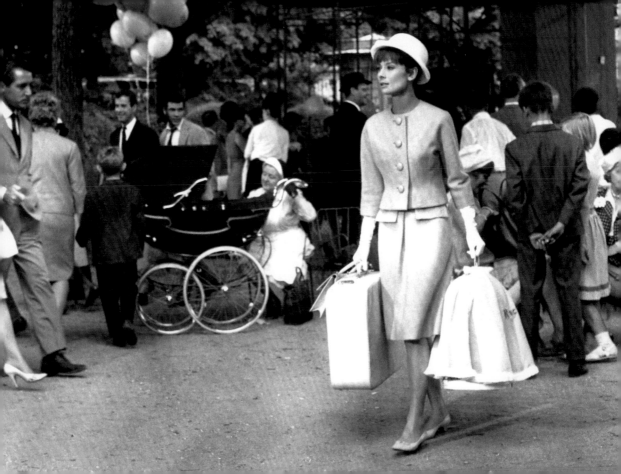

There were only two days for Audrey to rest in between the filming of *Paris When It Sizzles* and *Charade*. Both movies, filmed on location in Paris, featured a scene in a park that has a puppet show stage assembled.

Some of the more outrageous facets of Holly's character in
Breakfast at Tiffany's were toned down for Audrey.

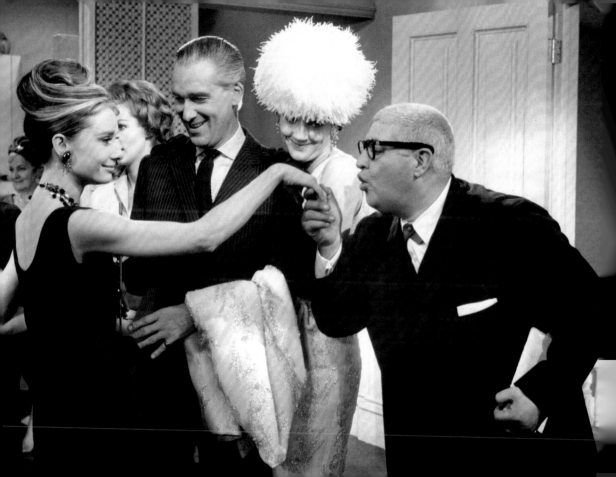

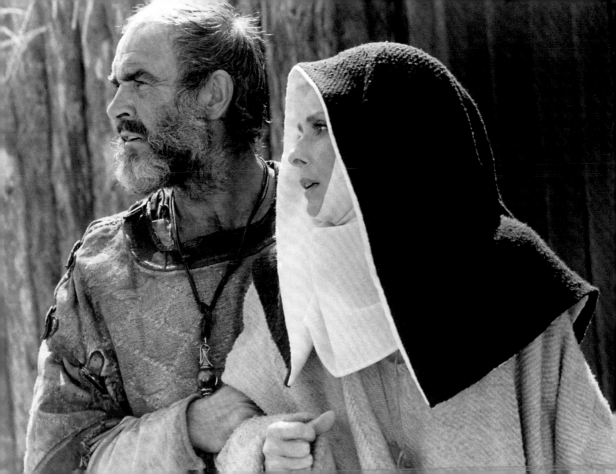

"*Robin and Marian* is really about how much two people
love each other. It's an intimate story,
and that's why I wanted to do it."
—Audrey Hepburn

One evening during the filming of *Paris When It Sizzles*, a drunk Bill Holden climbed a tree up to Audrey's room. When she came to the window, he kissed her and then promptly fell, plummeting to a parked car beneath the tree.

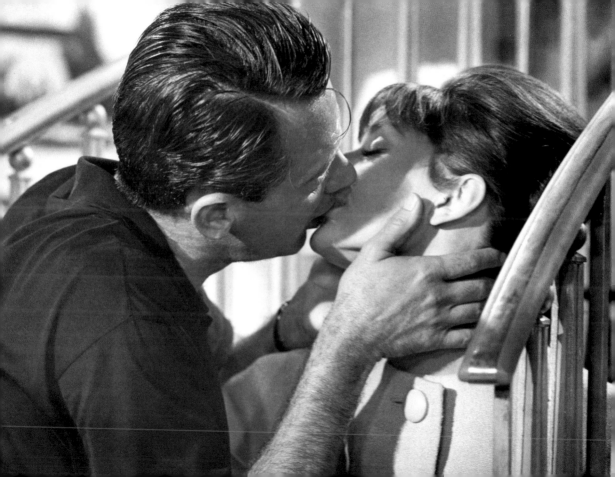

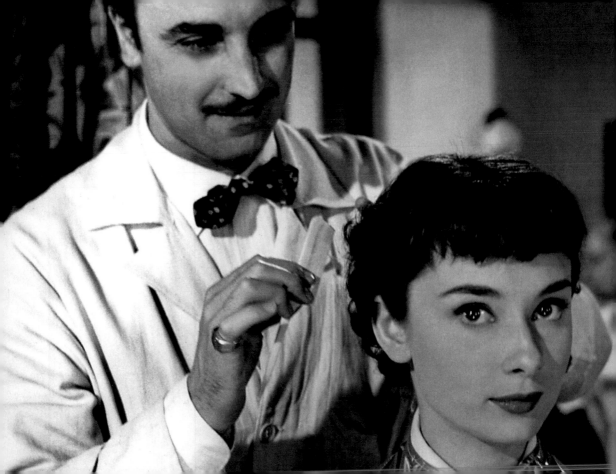

In the film *Roman Holiday*, Audrey's character receives a startling haircut as a symbol of maturity. This symbolic theme also happens to her character in *Sabrina*.

"Working with Cary is so easy. He does all
the acting and I just react."
—AUDREY HEPBURN ON WORKING WITH HER *CHARADE* COSTAR

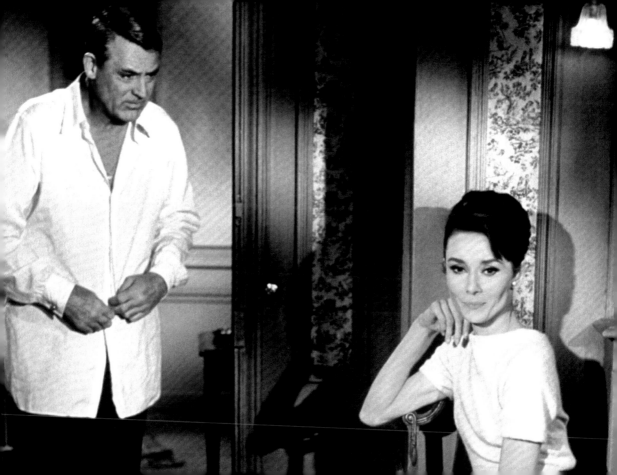

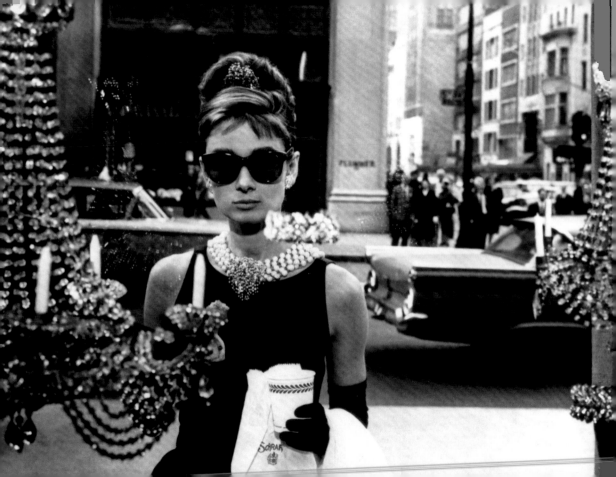

In the opening scene of *Breakfast at Tiffany's*, hundreds of people watched offscreen as Holly Golightly window-shopped. After several takes, an anxious Audrey completed the sequence despite the spectators.

"It was my good luck, during that wonderful summer in Rome, to be the first of her screen fellows, to hold out my hand, and help her keep her balance as she did her spins and pirouettes. Those months [were] probably the happiest experience I ever had making movies."
—GREGORY PECK

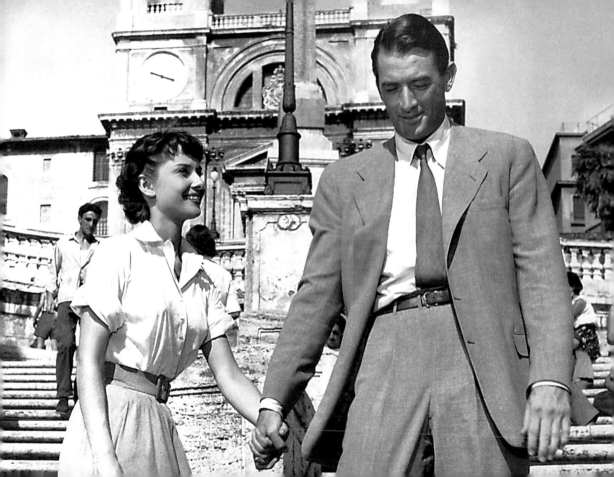

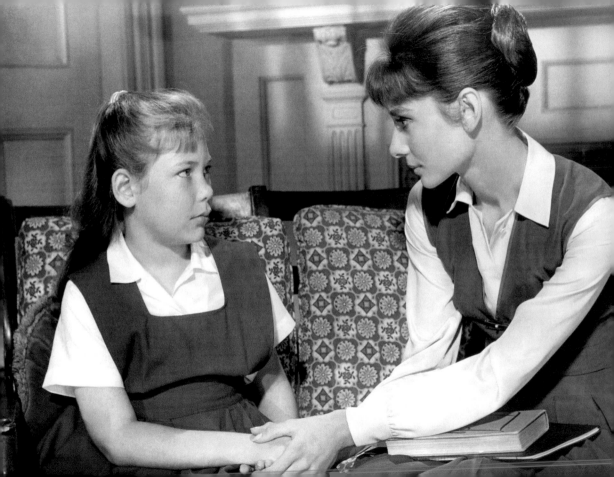

The Children's Hour was Audrey's last black and white film.

Jeremy Brett was chosen to play Nicholas in *War and Peace* because it was known that he resembled his on-screen sibling played by Audrey Hepburn.

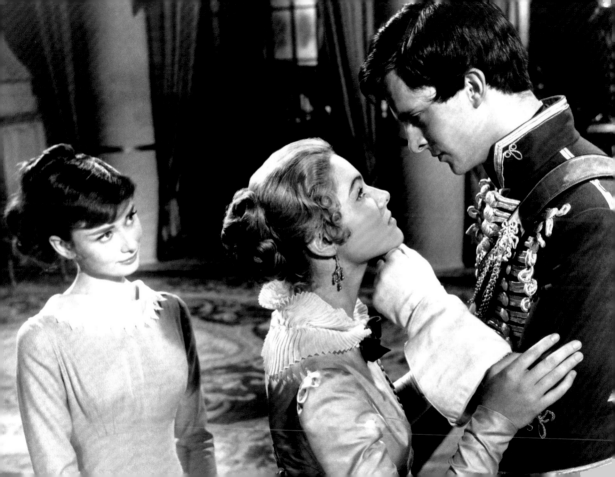

"Whether Audrey was in jeans and a bandana or all dolled up for the Oscars—she was so beautiful that you couldn't bear it."
—ANDRÉ PREVIN

According to Audrey, one of the most revolting things she had to do in character was dump her cat onto a rainy New York City street from the inside of a taxicab in *Breakfast at Tiffany's*.

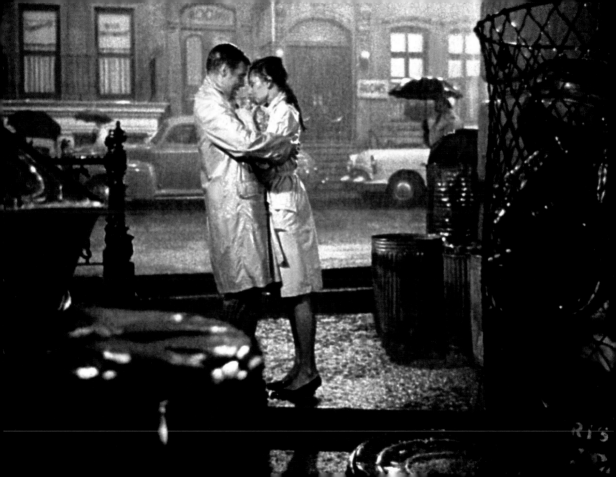

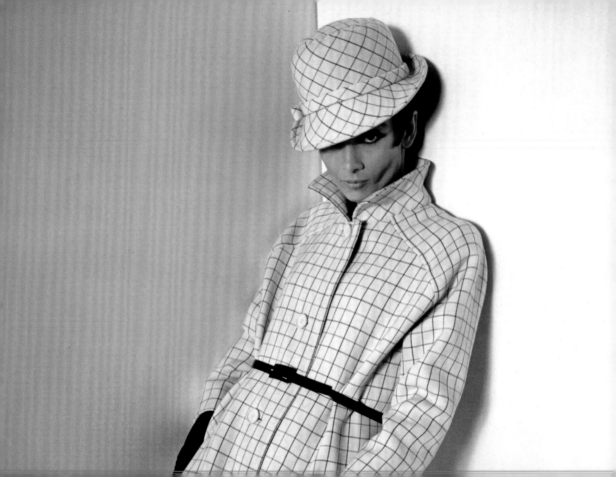

"Underneath, Audrey was a very sexual creature, always secretive and goddesslike. It would take some kind of godlike creature to bring her down—but she didn't seem to be too willing. She was a gamine goddess."
—JAMES COBURN

Although they had a marvelous time working together
on *Charade*, Audrey and Cary never starred
together in another film.

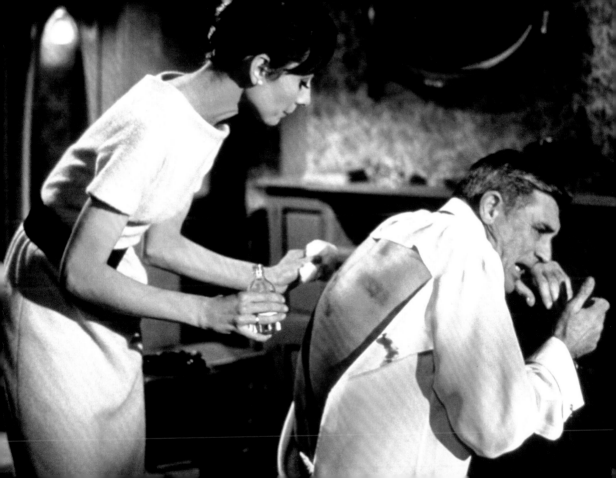

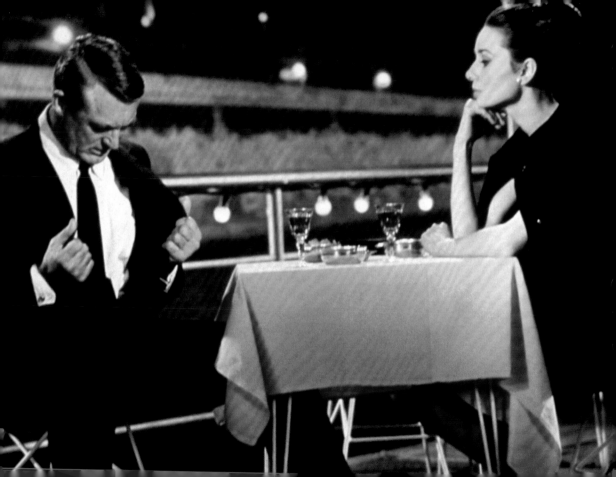

The scene in *Charade* in which Regina drops ice cream on Peter's suit is loosely based on the incident that occurred the first time Audrey and Cary were introduced. That evening, Audrey spilled a bottle of red wine all over him.

"Audrey Hepburn increases in dramatic stature. Intelligent and alert, wistful and enthusiastic, frank, yet tactful, assured without conceit and tender without sentimentality, she . . . gives every indication of being the most interesting public embodiment of our new feminine ideal."

—CECIL BEATON IN *VOGUE*

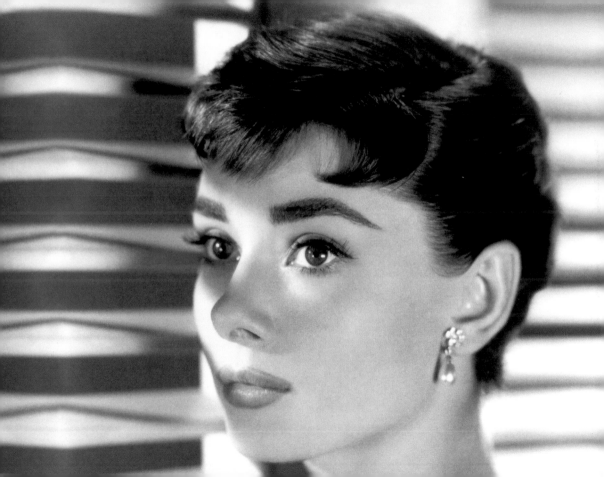

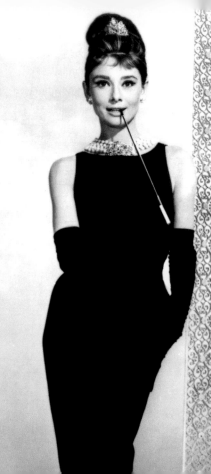

The famous black dress Audrey wore in *Breakfast at Tiffany's* became the second most expensive piece of movie memorabilia ever auctioned off. The auction took place at Christie's Auction House in London on December 4, 2006 for £467,200, just under a million dollars, well over its estimate of £70,000.

"That extraordinary mystique of hers made you think she lived on rose petals and listened to nothing but Mozart, but it wasn't true. She was quite funny and ribald. She could tell a dirty joke. She played charades with a great sense of fun and vulgarity, and she could be quite bitchy."

—ANDRÉ PREVIN

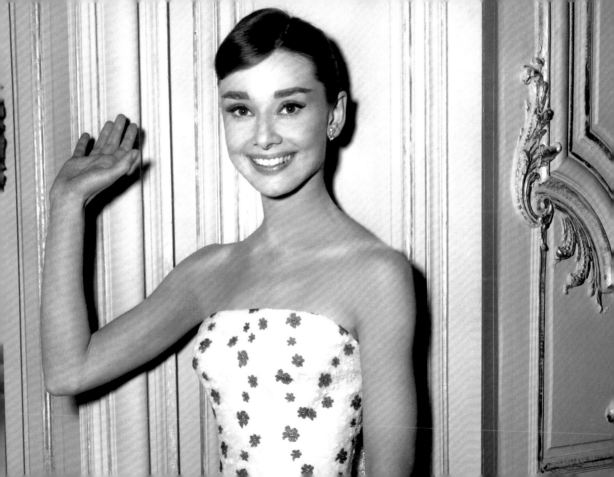

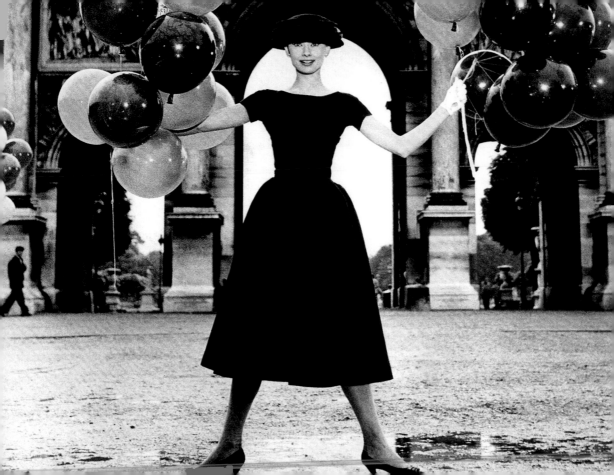

Paris's dismal rainy weather so pervaded the filming of *Funny Face* that it had to be worked into the script. This is most apparent in the balloon sequence.

William Holden didn't have to do much acting while filming *Sabrina* when he's smitten with Audrey's character, as he'd fallen for Audrey, too.

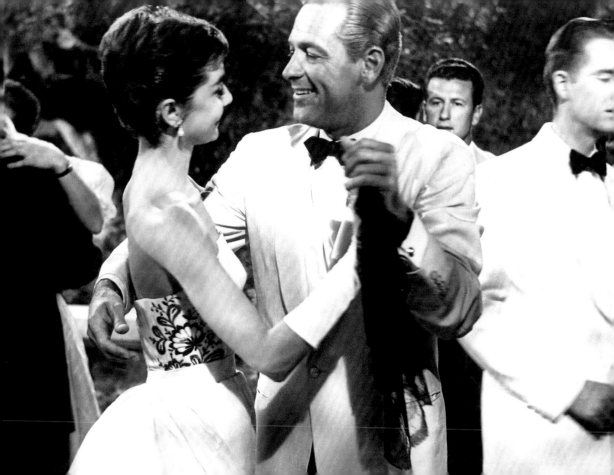

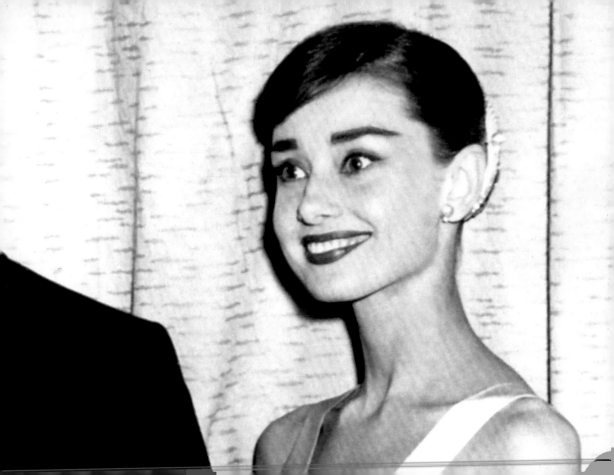

"A stick-slim actress with huge, limpid eyes and a heart-shaped
face. . . . She sparkles and glows with the fire
of a finely cut diamond."
—*TIME* MAGAZINE

Audrey played screen veteran Cary Grant's fiftieth leading lady in the film *Charade*.

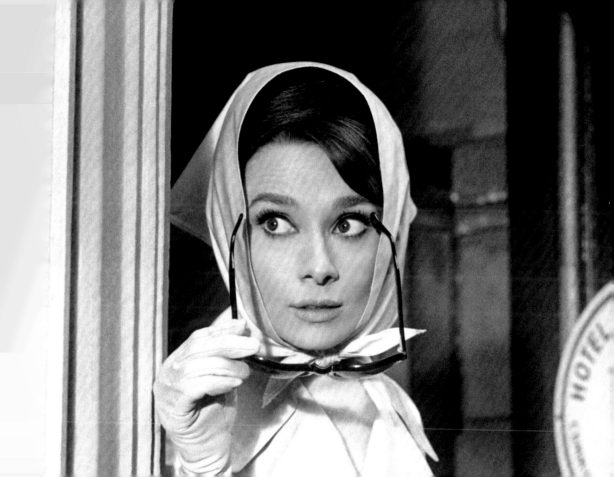

"*Robin and Marian* was really worth waiting for. There's a great need in films today for mature women to be seen playing mature women."
—AUDREY HEPBURN

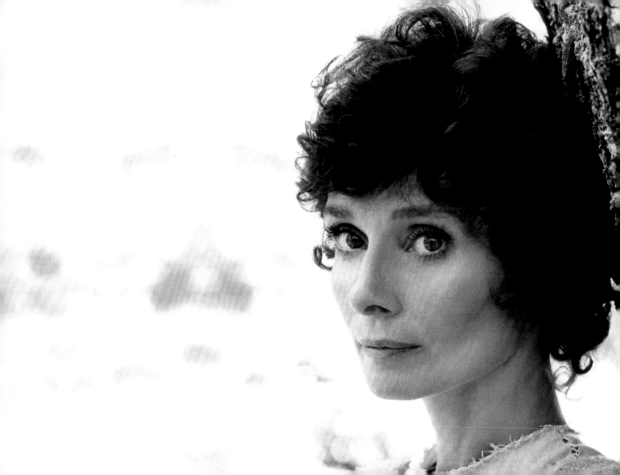

"She is that thin . . . Structurally, she has all the curves of a piece of melba toast—viewed from the side."

—Art Seidenbaum

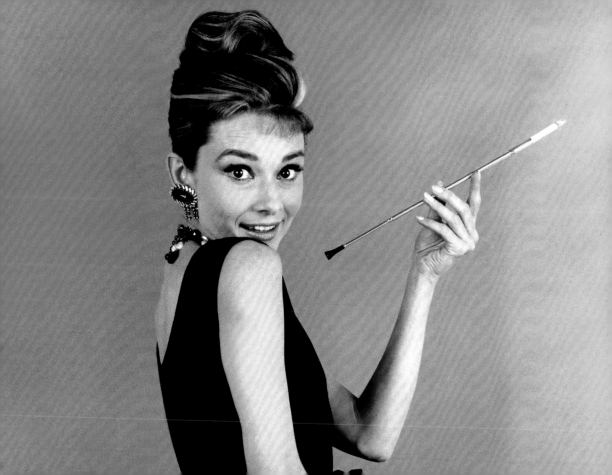

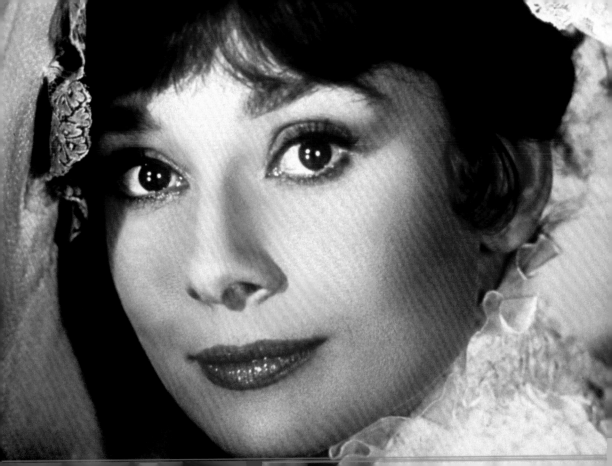

"She is like a portrait by Modigliani where the various distortions
are not only interesting in themselves, but make
a completely satisfying composite."
—CECIL BEATON IN *VOGUE*, NOVEMBER 1, 1954

Audrey did not want to be separated from husband Mel, so the shooting of the *Funny Face* was timed to concur with Ferrer's filming of *Elena et les hommes* in 1956.

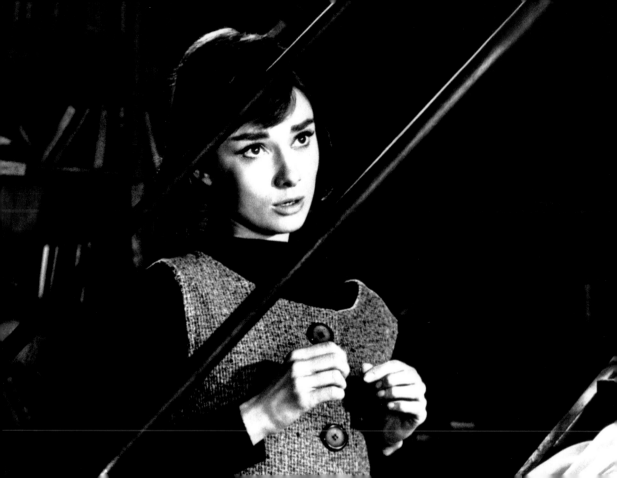

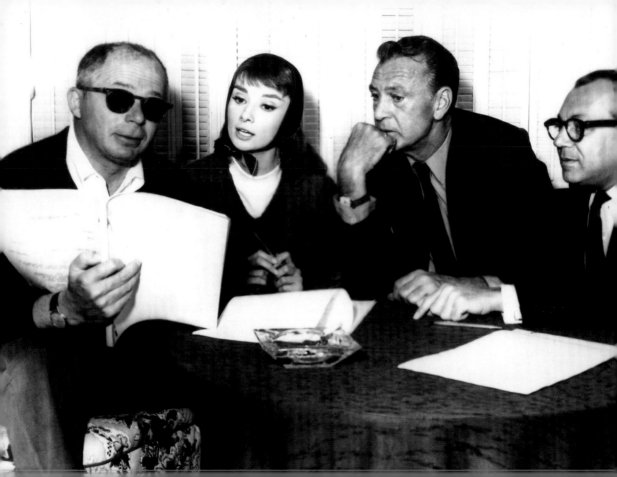

"I never expected to become an actress. My great passion was dancing. One of the great blows of my life was when I discovered I didn't have the native talent to become a prima ballerina. Nor, did I have the time or money to spend the necessary years to become an accomplished ballet performer.
So I had to turn to other fields."
—Audrey Hepburn

Peter O'Toole and Audrey Hepburn were notorious for causing each other to break out with giggles on the set of *How to Steal a Million*. "They react on each other like laughing gas," noted director William Wyler.

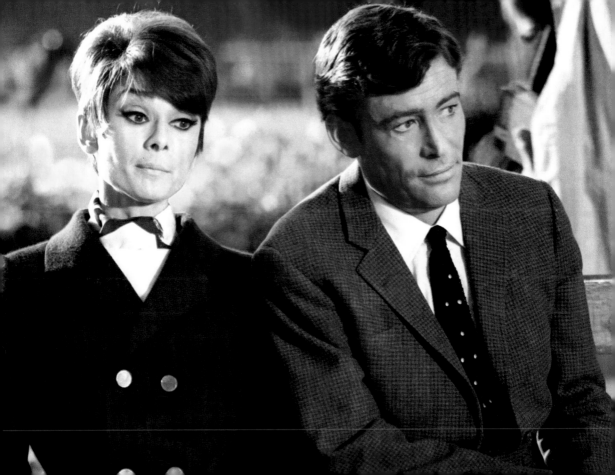

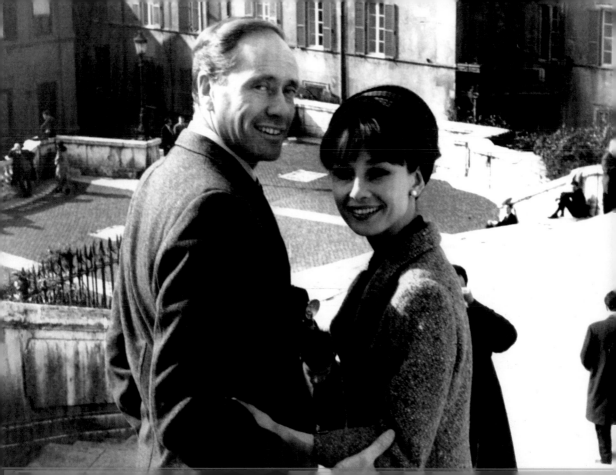

"Marriage is completion to everything I've ever
wanted and hoped for."
—AUDREY HEPBURN, SPEAKING ABOUT HER FIRST MARRIAGE
TO ACTOR-DIRECTOR MEL FERRER

"Hepburn and Finney are such a dream combination that they visually achieve such revelations of character, atmosphere, and emotion that their freshness and originality give the film a kind of vitality and continuance that seems easy."

—REX REED

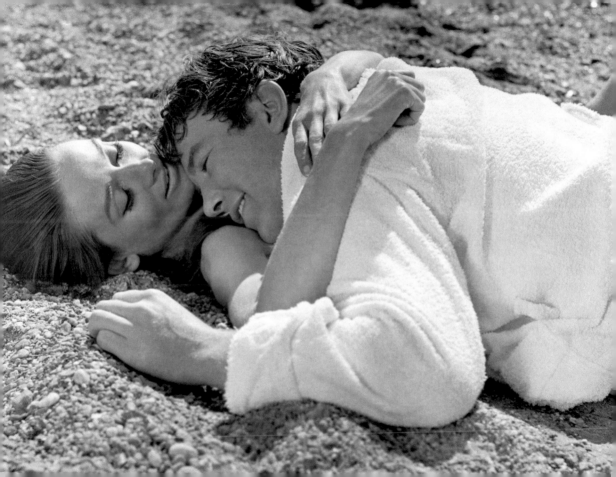

"Audrey is the kind of girl you would like to have on a desert island but not for the usual reason. You know that with Audrey around life would never be dull when you were alone."
—BILLY WILDER

"A perfectly balanced mixture of intelligence and froth."
—JANET MASLIN, DESCRIBING AUDREY'S PERFORMANCE IN
FUNNY FACE, IN THE *NEW YORK TIMES*, APRIL 21, 1991

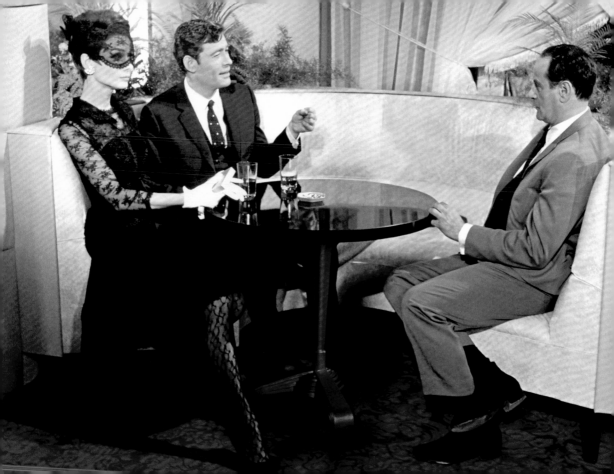

Givenchy designed many of the costumes that Audrey wore in her film, including this black dress and mask ensemble seen in *How to Steal a Million*.

"I wrote my first and only fan letter to her when she was in *Ondine* on Broadway. I loved her dearly. I was her No. 1 fan."
—Eddie Fisher, friend

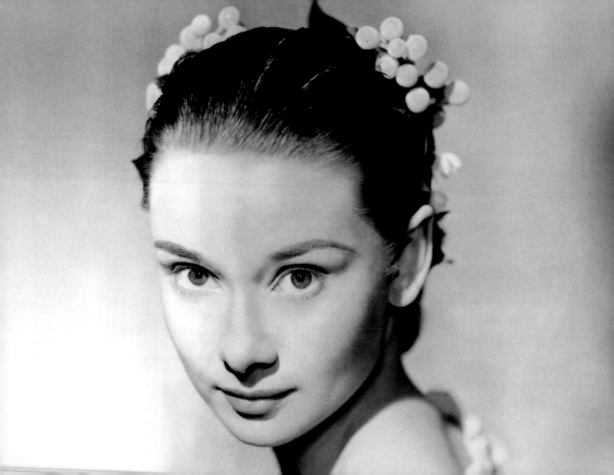

"She had a quality no other actress had: a curious combination of lady and pixie. She was a joy to work with—
enormous talent and no ego."
—SIDNEY SHELDON

Immediately after filming the "Wouldn't It Be Loverly" number on the set of *My Fair Lady* on November 22, 1963, Audrey Hepburn delivered the devastating news to the crew that President John F. Kennedy had been assassinated.

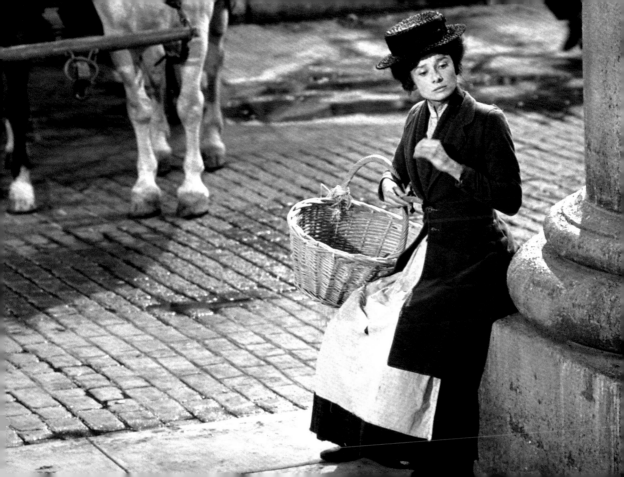

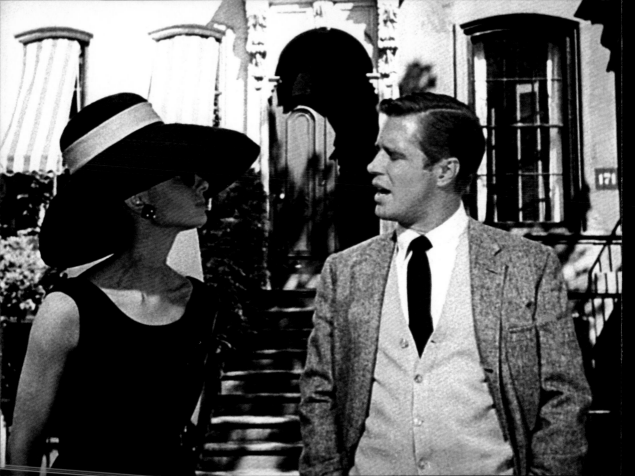

"I think sex is overrated. I don't have sex appeal and I know it.
As a matter of fact, I think I'm rather funny looking. My teeth
are funny, for one thing, and I have none of the attributes usually
required for a movie queen, including the shapeliness."
—AUDREY HEPBURN

"I was asked to act when I couldn't act. I was asked to sing 'Funny Face' when I couldn't sing, and dance with Fred Astaire when I couldn't dance—and do all sorts of thing I wasn't prepared for. Then I tried like mad to cope with it."

—AUDREY HEPBURN

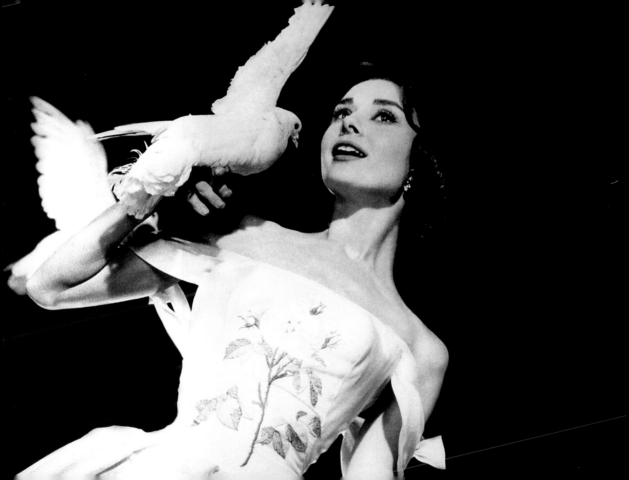

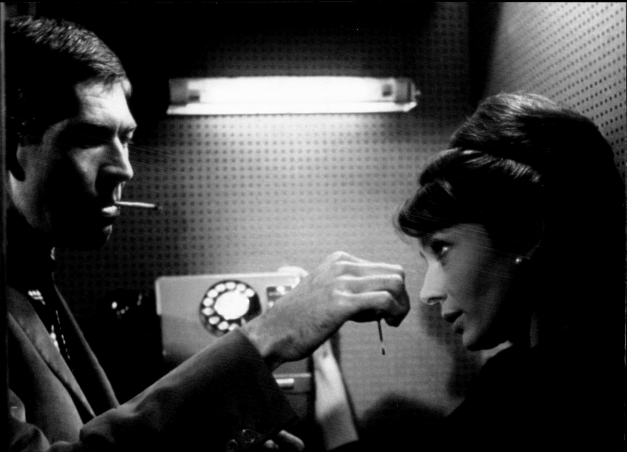

"I felt really bad about burning Audrey. It went against my
nature. Of course, we had it down so it wouldn't
hurt her. She was wonderful in that."
—JAMES COBURN ON THE PHONE BOOTH
SCENE IN *CHARADE*

"The last thing you want to be in acting is an introvert, which I am. I've never loved to perform. Oh, I liked it beforehand—all the preparation—and I like it afterward, if it went well. But the thing itself is scary!"
—AUDREY HEPBURN

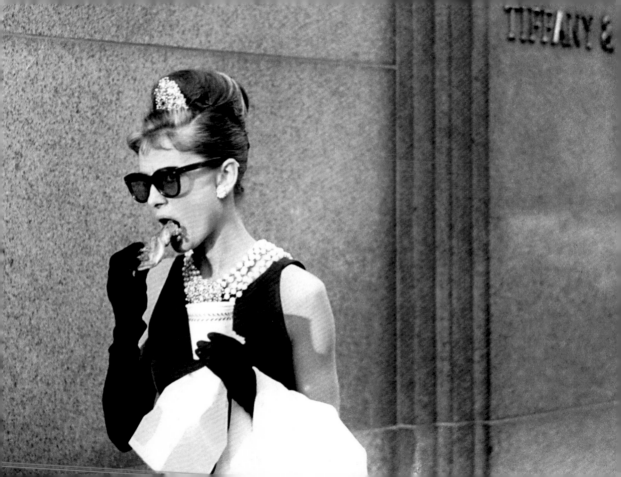

Audrey despised eating Danish pastry, yet she was required to munch one for the renowned scene in front of Tiffany's. She beseeched director Blake Edwards to let her eat something else, such as ice cream, but he would not relent.

"She has nothing to worry about. A lovely mobile face, an expressive body and the slimmest waist since the Civil War. Why you could get a dog collar around it. Her hat size is bigger than her waist size—twenty-two inches for the hat, twenty for the waist."
—Costume designer Edith Head

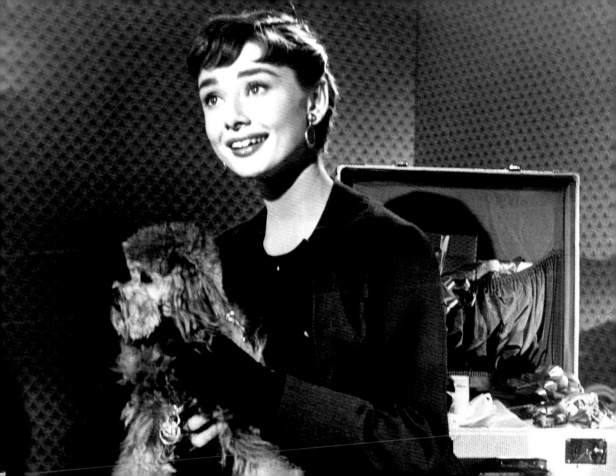

"I always love it when people write me and say 'I was having a rotten time and walked into a cinema and saw one of your movies and it made such a difference.'"
—AUDREY HEPBURN

"Before I even met Audrey, I had a crush on her, and after I met her, just a day later, I felt as if we were old friends . . . most men who worked with her felt both fatherly or brotherly about her, while harboring romantic feelings about her . . . she was the love of my life."
—WILLIAM HOLDEN

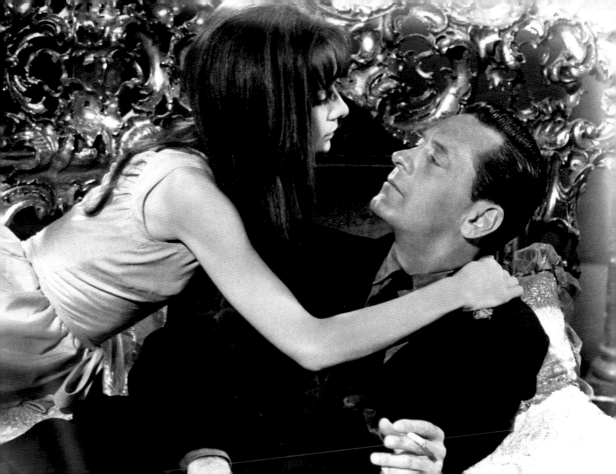

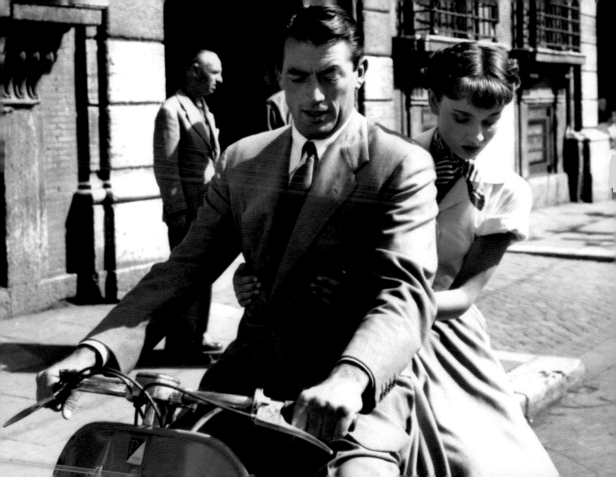

"She was as funny as she was beautiful. She was a magical combination of high chic and high spirits."
—GREGORY PECK

Charade was Audrey's highest grossing film when it was released in 1963. In addition to her $750,000 fee, she also got a percentage of the movie's gross profits.

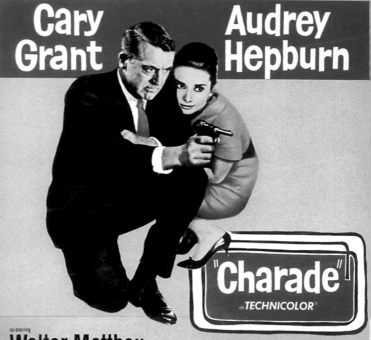

Expect the unexpected...when they become partners in danger...and delight!

Cary Grant

Audrey Hepburn

"Charade"
in TECHNICOLOR

co-starring
Walter Matthau · James Coburn · A STANLEY DONEN Production
Music by HENRY MANCINI · Screenplay by PETER STONE · Produced and Directed by STANLEY DONEN

A UNIVERSAL RELEASE

UNIVERSAL

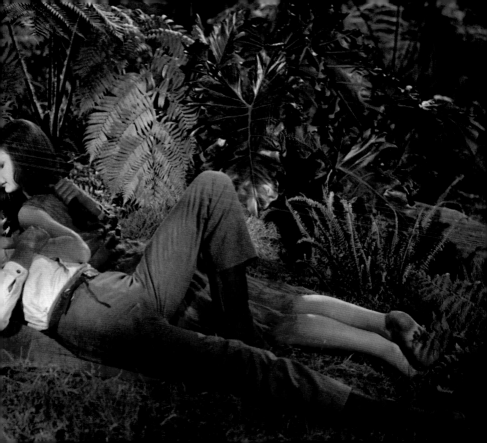

Mel Ferrer directed Audrey in *Green Mansions*.

"I never heard a vulgar word out of Audrey. I never heard anyone be vulgar in front of Audrey."
—BEN GAZZARA

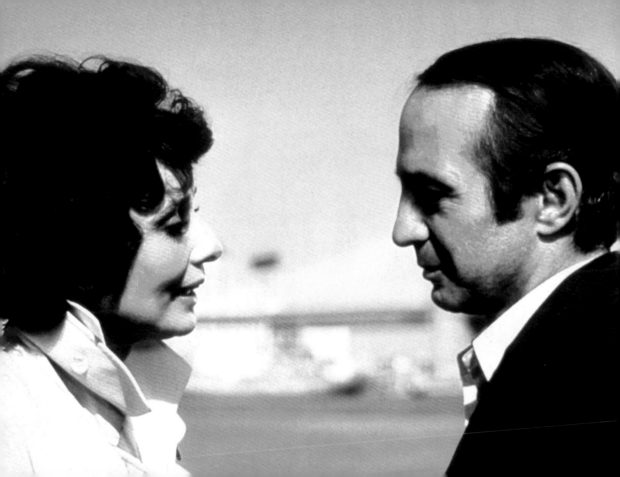

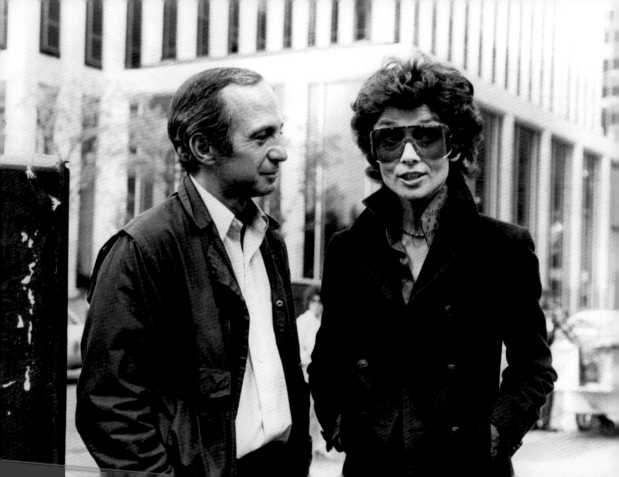

"She was lovely, so warm and thoughtful, talking to me while she stirred her pot of pasta. She had her own personal style. She was not created by a studio. She didn't need to be invented. She simply was."
—LINDA MacEWEN, COSTAR IN *THEY ALL LAUGHED* (1981)

"I had been playing ingénues since the early fifties, and I thought it would be wonderful to play somebody of my own age in something romantic and lovely."
—AUDREY HEPBURN ON HER ROLE IN *ROBIN AND MARIAN*

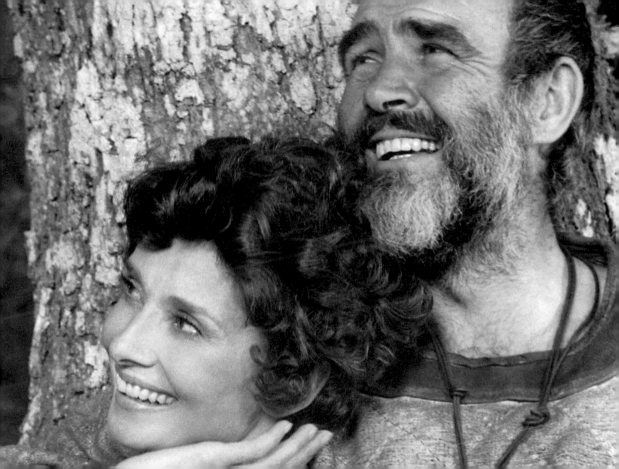

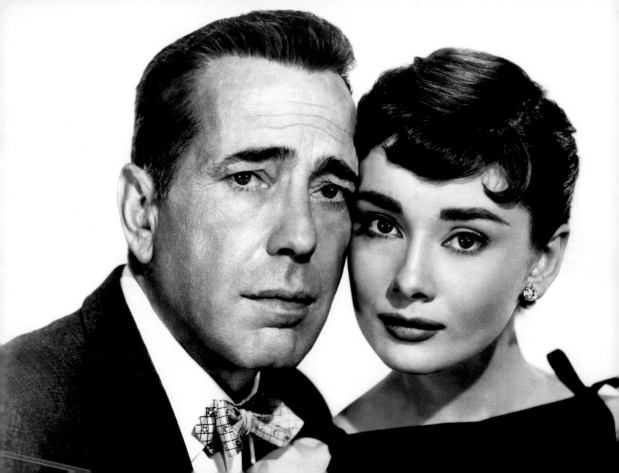

Sabrina is the first of four movies in a row where Audrey plays a character whose love interest is old enough to be her father. Gregory Peck, her *Roman Holiday* costar, had been a mere thirteen years Hepburn's senior.

"I never understood what makes me so special."
—AUDREY HEPBURN

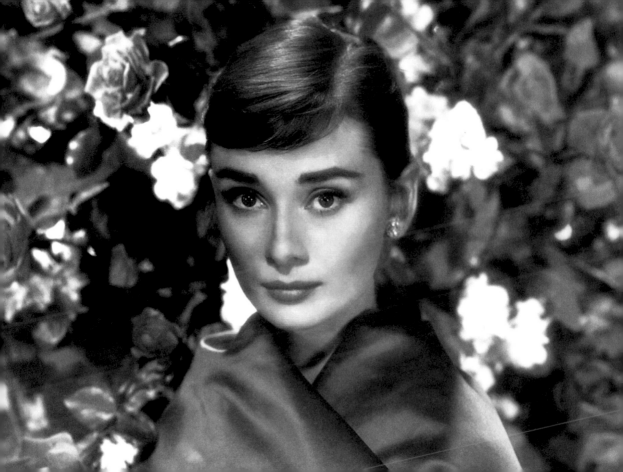

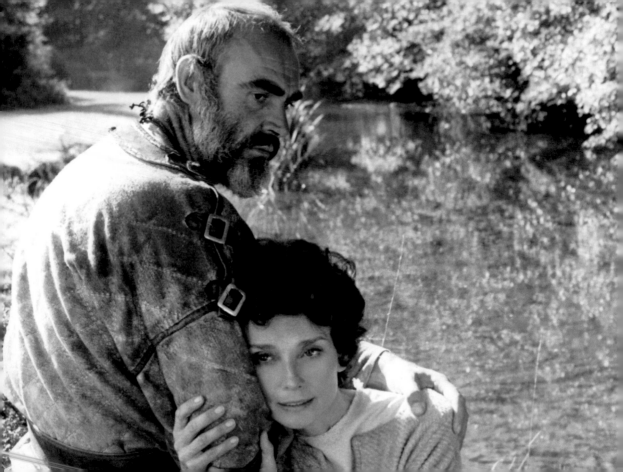

"It's what we grew up loving about movies, and Audrey Hepburn is one of the reasons we keep going, and loving them."
—REX REED ON AUDREY'S PERFORMANCE IN *ROBIN AND MARIAN*

"She and Albie had this wonderful thing together. It was like a brother-sister in their teens. When Mel was there . . . Audrey and Albie got rather formal and a little awkward, as if now they had to behave like grown-ups."
—Novelist Irwin Shaw describing Audrey and Albert Finney's working relationship

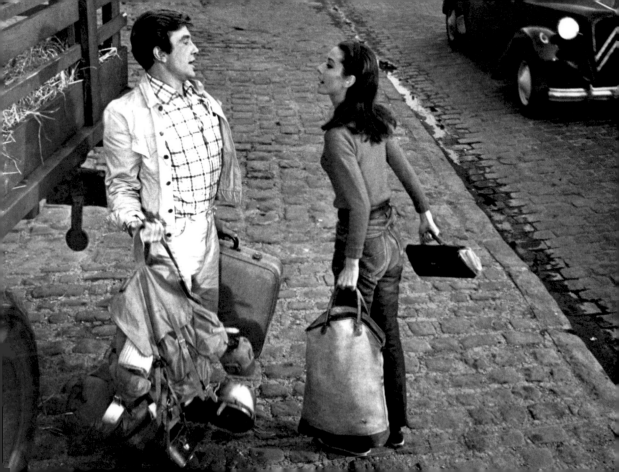

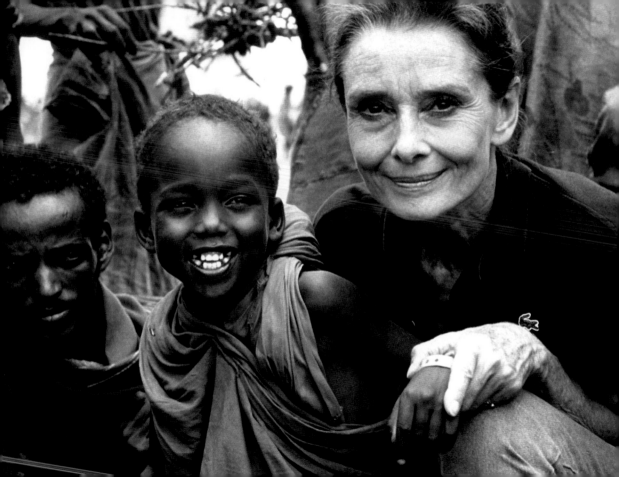

"She truly became our 'fair lady.' The children of the world have lost a true friend, and an important and eloquent advocate."
—UNICEF Executive Director James P. Grant

"I saw from [director] Willy [Wyler], when Audrey was working,
a sense of professional and personal admiration."
—PETER O'TOOLE

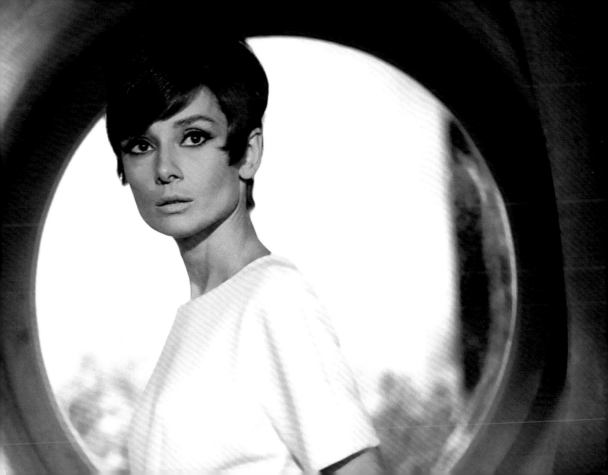

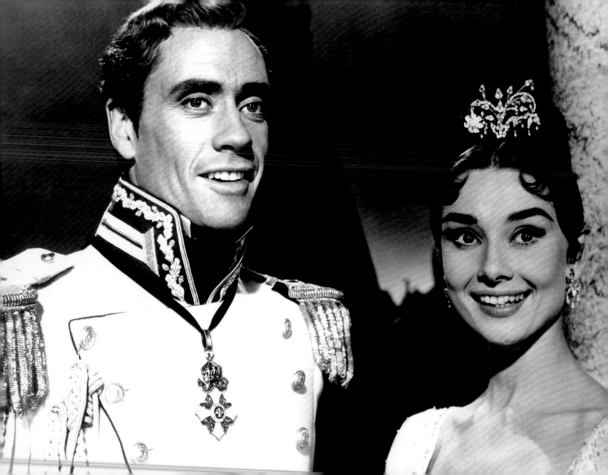

For the costume drama *War and Peace,* Audrey earned a salary
of more than three times what her husband Mel
earned for the same film.

"I think, in retrospect, it was that Audrey was such a lady herself. You knew she wasn't a real princess, but you still gave her deferential treatment. She had class that the average young American girl never had. And, you know, she never changed all her life. All the years that I knew her and worked with her."
—BOB WILLOUGHBY, PHOTOGRAPHER

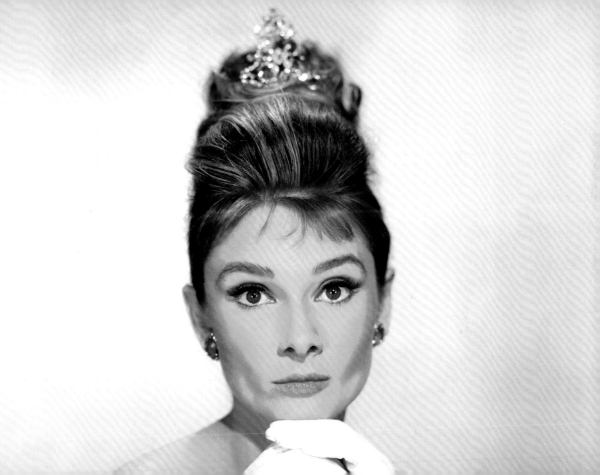

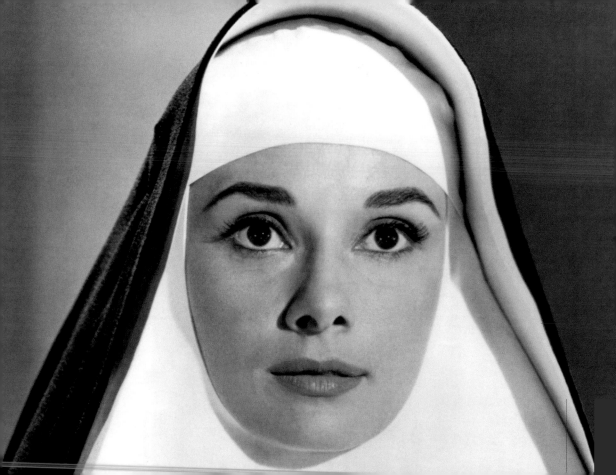

Audrey spent time in a real nunnery, the Oblates d'Assomption, in order to observe the day-to-day life of a nun in preparation for her role as Sister Luke.

"I have to be alone very often. I'd be quite happy if I spent from
Saturday night until Monday morning alone
in my apartment. That's how I refuel."
—AUDREY HEPBURN

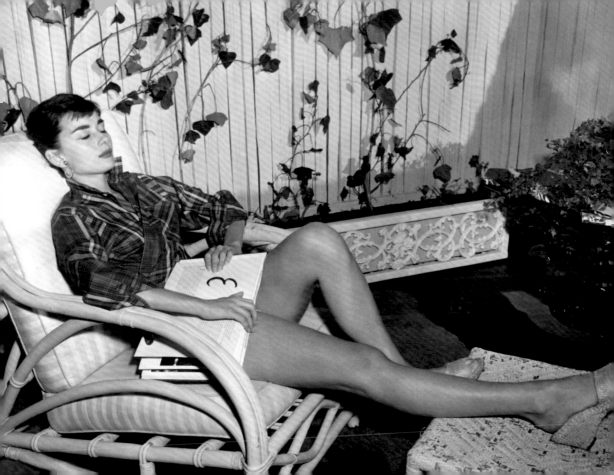

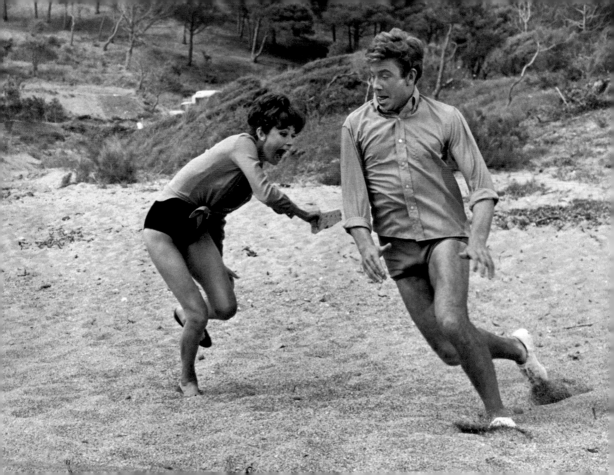

Typically known to be quiet and subdued on a film set,
Audrey became much more social, engaging in horseplay and
conversation during the making of *Two for the Road*.
Many attributed this to the youthful effects
of her costar, Albert Finney.

"She deliberately looked different from other women [and]
dramatized her slenderness into her chief asset."
—EDDIE FISHER

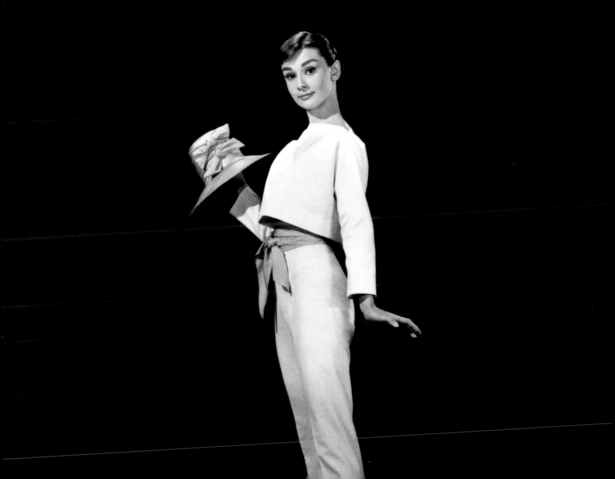

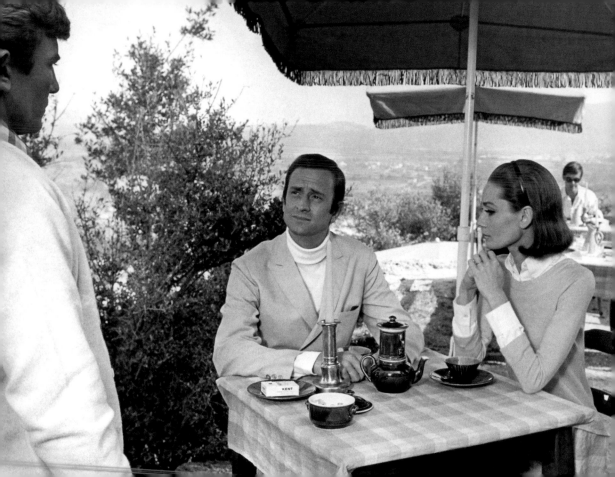

Both cast and crew approached the filming of the scene in *Two for the Road* in which Mark confronts Joanna's infidelity with some trepidation, as the realistic subject matter made most of them uncomfortable—and the possibility that the movie's stars were having their own romance didn't help matters.

"Since I was a child, I've believed in prayer. I have this faith that things somehow work out."

—AUDREY HEPBURN

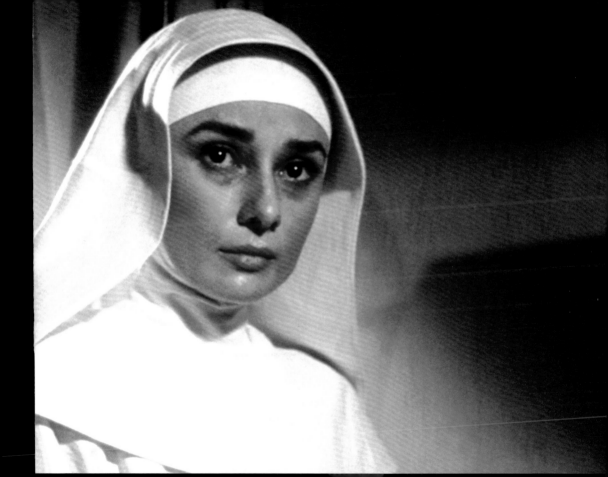

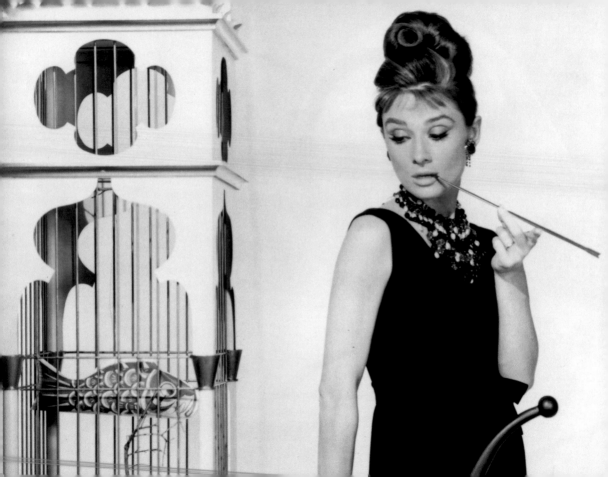

"I won't misbehave because I think stars who are in the public eye also owe it to the public to behave with dignity. I'm not sure being teamed romantically with other players is dignified."
—AUDREY HEPBURN

William Wyler cut several scenes hinting at Martha's homosexuality in *The Childrens' Hour* because he didn't want trouble from the Motion Picture Production Code.

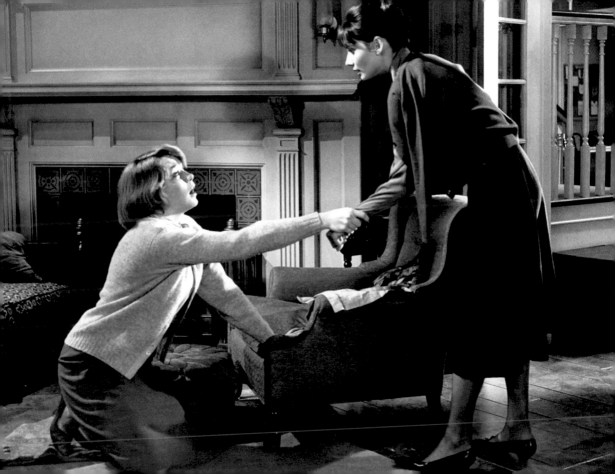

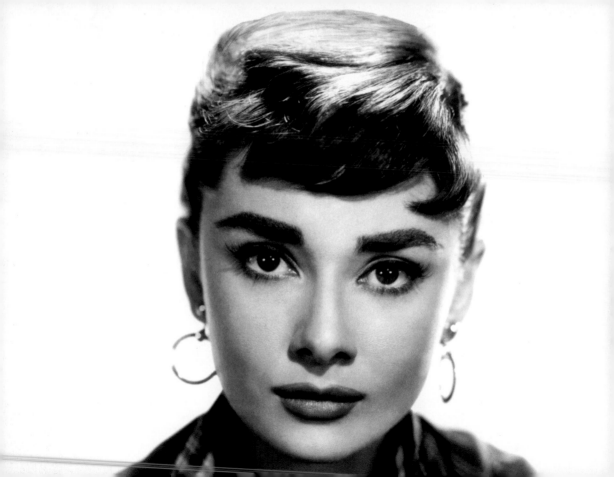

"Quite a lovely heritage she's left in this world, the films people can see and the joy that she gives them, and I can think of no more beautiful model to try to be like for the young people today because there are not many like her that one would want to emulate."
—CONNIE WALD, HEPBURN'S BEST FRIEND

"Audrey gave more than she ever got. The whole world is going to miss her."
—STEVEN SPIELBERG

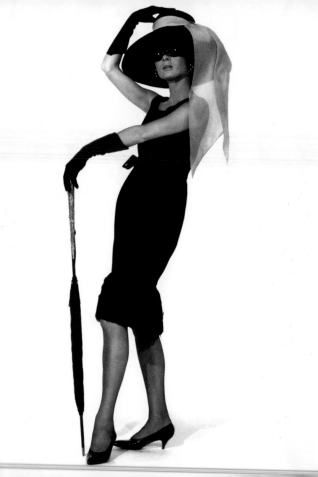

"This is the best thing I've ever done, because it was the hardest."
—AUDREY HEPBURN ON HER ROLE IN *BREAKFAST AT TIFFANY'S*

"There is no doubt that the princess did become a queen—not only on the screen. One of the most loved, one of the most skillful, one of the most intelligent, one of the most sensitive, charming actresses—and friends, in my life—but also in the later stages of her life, the UNICEF ambassador to the children of the world. The generosity, sensitivity, the nobility of her service to the children of the world and the mothers of the world will never be forgotten."
—GREGORY PECK

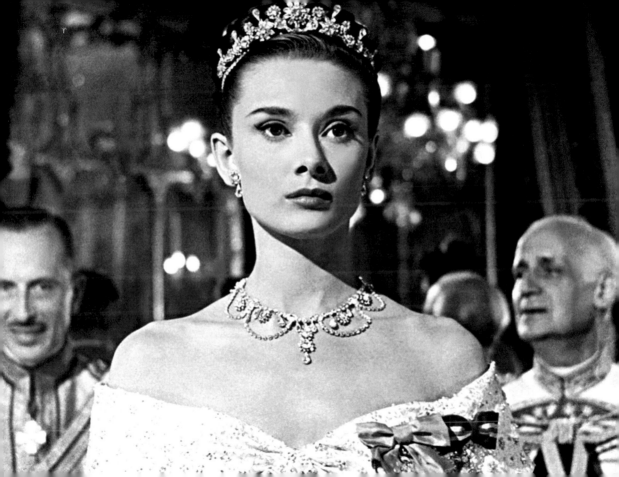

"There's never been a helluva lot to say about me."
—AUDREY HEPBURN

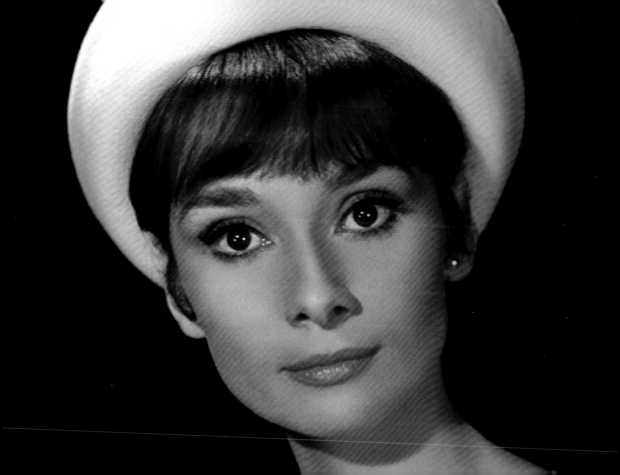

PHOTOGRAPHY CREDITS

Photofest (all images except as noted below)

p. 163 Ulrich Felzmann Auction House
 catalogue, October 2007

p. 256 Karen Schmidt

p. 271 The Playwrights' Company, 1954

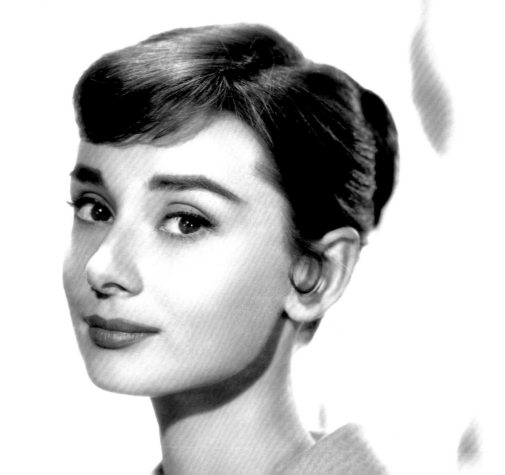

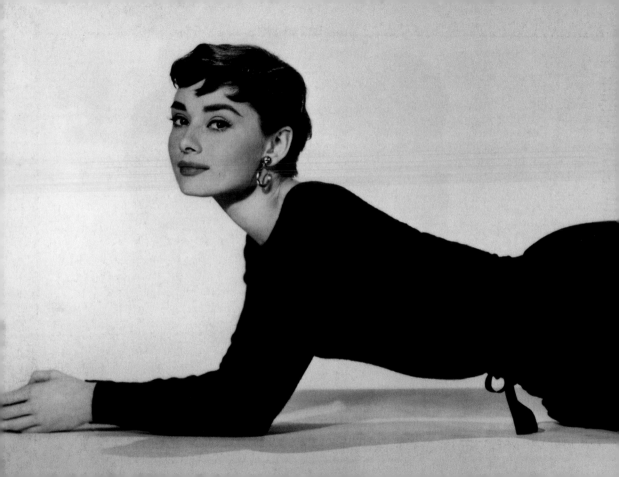